# BRUEGEL

*The life and work of the artist illustrated with 80 colour plates*

**ARTURO BOVI**

**THAMES AND HUDSON**

Translated from the Italian by Pearl Sanders.

This edition © 1971 Thames and Hudson, 30-34 Bloomsbury Street, London WC1
Copyright © 1970 by Sansoni Editore, Firenze.

Printed in Italy                                              ISBN 0 500 41043 7

# Life

Pieter Bruegel was born near Breda, in North Brabant, between 1520 and 1530. The exact date of his birth is unknown, but we do know that he died in 1569 in the 'middle flower of his age' (according to his friend the geographer Abraham Ortelius), and that he became a member of the Antwerp guild of painters, for which the minimum age of admission was twenty-five, in 1551. He would thus have been born about 1525.

We are again in ignorance about his early masters. According to Carel Van Mander's 'Book of Painters', written about 1600, he was a pupil of Pieter Coecke van Aelst, at his studio in Brussels. Coecke was a cultured artist, mentioned by Vasari. He worked in Italy and Turkey as a painter and designer of cartoons for tapestries and stained glass. He was dean of the Guild of St Luke, an architect, and the translator of Vitruvius and Serlio. He left a very accurate version of Serlio's works, which was completed after his death by his wife, Mayeken Verhulst Beessemers of Malines, who was herself a painter and miniaturist. Van Mander relates that when Bruegel was a young man in his master's house he used to carry about in his arms Coecke's young daughter — the girl who was to become his wife in 1563 (a record of the marriage exists in the church of Notre Dame de la Chapelle, in Brussels). The first documented date in Bruegel's life, 1551, is that of the entry recording his admission to the Guild of St Luke in Antwerp, and it is extremely interesting to note that the name above his in the register is that of Giorgio Mantovano, or Ghisi, who in 1550 had copied on to tiles Raphael's famous cartoon *St Paul in Athens.* This was Bruegel's first contact with the art of Italy.

In 1555 he is recorded as working with Hieronymus Cock, publisher of engravings and etchings and an engraver himself, whose busy workshop at the sign of the Four Winds was a cultural centre and meeting place for art lovers, scholars and men of letters. Many of Cock's prints

were taken from Italian paintings, by Michelangelo, Raphael and Titian, especially landscapes. It seemed to Van Mander that the time he spent engraving these Italian works for Cock was as fundamental to Bruegel's development as his great admiration for Hieronymus Bosch, whose works he may have seen as a young man at 's Hertogenbosch.

One of the most interesting points to be considered in the case of Pieter Bruegel, which will be discussed in the following section dealing with his works, is to what extent and in what direction he was influenced by the Italian Renaissance, and at what point he had to reject those influences when had become incompatible with his own vision. In the same way, one must examine the relationship of his work to that of Bosch — the similarities, but also the dissimilarities due to their difference both in age (Bosch died in 1516) and in personality.

Some of Pieter Bruegel's drawings and paintings contain unmistakable evidence of his journey to Italy in 1552-3, during which he was in contact with Marten de Vos. Some years later, in April 1564, the geographer Scipio Fabius, writing from Bologna to his colleague Ortelius, sent greetings to both artists, whom he must have met some ten years earlier during their stay in Italy

Bruegel's exact itinerary in France and Italy is not known. We can see references to certain places in some of the drawings and paintings, although these are sometimes merely hinted at. Literary documentation of his journey to the south seems to be confined to this note by Van Mander: 'He went to France and thence to Italy'; but we may guess that he visited Naples from the *View of Naples* (*pls 1-3*), a painting acknowledged by most scholars to be an early work and referred to in the inventories of both Granvelle (Besançon, 1607) and Rubens (Antwerp, 1640) as the work of Bruegel. Another drawing by Bruegel, of Reggio da Calabria (Museum Boymans-van Beuningen, Rotterdam), contains details from which one can deduce the exact year of his visit to that city: that this was 1552 is shown by the fires burning over the town, caused by the Turkish attack on Reggio in that year. We can follow the artist's journey across the Straits of Messina, not only

because of the engraving by Frans Huys mentioned above, but because extremely precise features of the town of Messina appear in an engraving by Cock, made in the same year, which bears the inscription *Hieronymus Cock pictor excudebat M.D.LXI. Cum gratia et privilegio Bruegel inuen.* On the other hand it is not at all certain whether Bruegel visited Palermo, although Goldscheider sees similarity between the fresco in the Palazzo Sclafani in that city and Bruegel's famous portrayal of the same theme, *The Triumph of Death* (Prado, Madrid) executed in the last years of his life.

In 1553 Pieter Bruegel was in Rome. This visit is documented by his drawing of the Ripa Grande, with an inscription in his own hand, and two well-known landscape engravings after his drawing, one representing *Psyche and Mercury* and the other *Daedalus and Icarus*, both inscribed *Petrus Bruegel fec. Romae Ao 1553.*

During his stay in Rome Bruegel made excursions into the surrounding countryside: Cock engraved a view of the Tiber, *Prospectus Tiburtinus*, after one of his drawings. This engraving is of interest stylistically for the flowing rhythmic line of the landscape in the foreground, which seems a sketch of a monstrous and remote geological past. Bruegel's crossing of the Alps, during his Italian journey, engendered in him that mysterious sensation of cosmic space which was to be a fruitful source of inspiration throughout his life. A drawing of Mount Martinswand, near Innsbruck in the heart of the Tyrol (in the Berlin Kupferstichkabinett; thought by Charles de Tolnay to be a copy), gives some indication of the impact of this experience, as do other drawings of Alpine views ascribed to Bruegel by both Tolnay and Otto Benesch. One of these shows the valley of the Ticino south of the St Gotthard Pass; a painting of this subject is recorded in the inventory of works by Bruegel owned by Rubens.

In 1555 Bruegel settled in Antwerp where as we have seen, he worked for the engraver Cock. His great landscape series belongs to the years 1554-8, while the two important series of *Seven Virtues* and *Seven Capital Sins* were painted in 1557-60. In Antwerp Bruegel met people who became

important to him as a man and as an artist, and provided him with experience which he later found indispensable. His patron Niclaes Jonghelinck purchased sixteen of his works and introduced Bruegel to Cardinal Perrenot de Granvelle, Governor of the Netherlands; the cardinal was an art collector and took Bruegel under his protection. Among his friends Bruegel numbered men of culture like the geographer Abraham Ortelius, the philosopher and engraver Coornahert, the typographer Plantin and the archaeologist Goltzius. Van Mander writes of his connections with the Nuremberg merchant Hans Franckert: 'With this Franckert, Breughel often went out into the country to see the peasants at their fairs and weddings. Disguised as peasants they brought gifts like the other guests, claiming relationship or kinship with the bride or groom.'

The historical period in which Bruegel lived was without doubt one of complexity, drama and hardship. It was an age not only of economic expansion, but of profound social transformations, religious crises and political upheavals. The Reformation of Luther was at hand, and if preachers were bringing the message of freedom and comfort, these benefits were bound up with compromises and bitter struggles. The iconoclasts' revolt against tradition stirred men's consciences, while the ascent of Philip II to the throne of Spain marked the beginning of persecutions and massacres which culminated in the relentless repression of the Duke of Alba in 1567. Bruegel lived long enough to observe these ferments and their dramatic outcome. And if on the one hand in his thought Bruegel came close to the ironical view of human vanity expressed in Erasmus' *In Praise of Folly*, yet on the other hand many aspects of his work show a degree of endurance and submission which enabled him to observe and analyse in an entirely realistic manner the thoughts and actions of man, and to bring to his subject a singular and powerful imagination ranging over an entire universe of human nature, from the humblest to the mightiest. It seems quite plausible that when in 1563, after his marriage to Coecke's daughter, Bruegel left Antwerp for Brussels, this departure was not for private reasons alone, but on grounds of caution. The

move might seem prudent, in view of the social and political allusions which could be discovered in his works, as well as the too revealing inscriptions he added to his drawings. According to Gotthard Jedlicka (*Pieter Bruegel*, 1947), Bruegel was a sectarian heretic, and a charge of this nature was sufficient to exile Plantin to Paris. At all events Bruegel left Antwerp, where he had spent many prosperous years and become known among his circle of friends as an easy-going, good-tempered man, saying little but often quick to joke.

In Brussels two sons were born of his marriage to Maria Coecke: Jan, known as 'Velvet Bruegel', and Pieter, 'Hell Bruegel'. Here Bruegel was to find understanding and recognition. On 18 January 1569 the municipality exempted him from the duty of providing a billet for Spanish soldiers and also granted him a gratuity as an advance on a commission for a painting. Shortly before his death he was entrusted with the official commission of preparing cartoons for tapestries to illustrate the digging of the canal between Brussels and Antwerp, which was completed in 1565. This commission remained unfinished and again it is Van Mander who tells of it, as well as of the artist's desire, expressed on his deathbed, to burn many 'of his strange and complicated allegories... drawn to perfection and bearing inscriptions', since they were 'offensive and biting, or because he repented of them, or of fear his wife might suffer harm or annoyance on their account'. On 5 September 1569 Bruegel died; he was buried in the church of Notre Dame de la Chapelle in Brussels, where his son Jan erected a tomb embellished with a painting by Rubens. The tomb was restored in 1676 by his grand-nephew David Teniers III, who added an inscription relating to the artist's wife, who died ten years after him and had brought up her children to a love of art inherited from their grandmother, the painter and miniaturist. Bruegel's thoughtful, serious face is known from two engravings, by Lampsonius and Sadeler.

# Works

It might be said that Flemish landscape was born with Jan van Eyck as the abode of the Divine. With Pieter Bruegel it takes on a reality and significance of its own, as the scene of human activity: people live in it, even though nature many dominate or be indifferent to them. And man, for Bruegel, is no longer to be seen either in relation to an ideal or metaphysical world of redemption (as in Van Eyck), or as a vile sinner waiting to be annihilated by the dread monsters of the forces of evil (as in Bosch). For Bruegel man is to be discovered and portrayed in his human reality, as a being dominated largely by instinct, and certainly not guided by the light of reason. Man's 'natural' fate therefore grows out of his 'own nature'; it is brought about by his ignorance and mediocrity, by greed, or a presumptuous craving for power which can create, among the humble no less than the mighty, a fatal Tower of Babel.

'Bosch', writes Tolnay in *Pierre Bruegel l'ancien* (Brussels 1935), 'was born at the time of the break-up of the mediaeval cosmic system, and his work marks the abyss between the Kingdom of God and the profane world, now a prey to demons. Bruegel's mission is to suppress the dualism of creator and created, by rejecting all forms of the supernatural; he creates a synthesis between nature and the soul of man, and this new nature bears within itself its own vital principle.' It is an extremely negative vital principle, the fruit of that inner brutalization of man's spirit which Bruegel observed so closely. This passion for observation is what lies behind his rejection of the religious vision of Jan van Eyck or Rogier van der Weyden, and behind his only very limited interest in Bosch. There is of course an affinity between him and Bosch, who could create the clearly individuated figures that crowd round Christ in *Christ carrying the Cross* (Ghent Museum) or *Christ Mocked* (National Gallery, London), and who set the story of *The Prodigal Son* (Museum Boymans-van Beuningen,

Rotterdam) in contemporary Flanders. But the Bosch of *The Garden of Earthly Delights* (Prado, Madrid) or *Hell* (on the doors of his picture *The Haywain*, in the Escorial) interested Bruegel only for his inventiveness and powerful imagination coupled with subtlety of expression. In these particular works Bosch expresses the mediaeval belief in demons and occult forces; his imagination turns away from human reality towards a cruel world of fantasy, in which nature is violated and deformed. For Bruegel it is quite the opposite: reality is to be investigated through direct experience. The human beings he knows may sometimes, in their daily life, bear the fruits they are capable of producing; but the world in which they live is certainly not generous towards them. Nature is indeed often hostile to man; in its vast reaches and deep winter frosts it reduces him to wretchedness and drains him of all strength.

The problem is therefore always one of leading us back to a vision of reality. As the artist of this Northern Renaissance humanism, Bruegel's position is opposed to the spirit of the Italian Renaissance. This is especially apparent when we think of Michelangelo, a comparison made by G. C. Argan in 'Cultura e realismo in Pieter Bruegel' (*Letteratura*, 1955). Michelangelo pursues an ideal of inner beauty which lends strength to the solitude of his spirit and to his urge to express the titanic struggle between the forces for good and evil in the human conscience: it is not the study of the individual which interests him, but the universal problem of man. In contrast, Bruegel studies the human condition as he sees it reflected in the society of his time, and his observation of nature rejects idealization to depend only upon an objective analysis of individual human characters. The purpose of this analysis was not to build up a scientific method for the study of mankind and nature, as was the case with Leonardo, but like him Bruegel took actuality as his starting point. We are told by Sabba da Castiglione that Leonardo made sketches of individual faces seen in the Borghetto at Milan; in the same way, as we know from Van Mander, Bruegel mingled with crowds of peasants at their village fairs and weddings. There he could observe how they lived, and

could study their features and movements as they abandoned themselves to that sweet sleep of 'reason' to which they were by temperament strangers. Leonardo drew from life to create a whole world of knowledge out of his own experience; his eye and mind mirrored the individual nature of man and his character, expressed as a tension between 'motion' (*Codex Atlanticus*, fol. 109v, *a*) and 'apparent calm' (Institut de France, MS A, fol. 60r). Bruegel was dealing with a similar problem, although in his own way and to suit the needs of his personal vision — that is, as an observer of the society of his time and the people of his own country. For Bruegel expresses through line and colour both the movement of humanity — not only in *The Peasant Dance* (*pls 74-5*), as we shall see — and the apparent calm which may be shown to exist in man and in nature (see, for instance, *Hunters in the Snow, pls 38-9*). The tension between 'motion' and 'apparent calm' is present in all Bruegel's works; through it he explores the forces of life and death which are inter-related in the existence of man even when they seem to take different forms of expression. This appears not only in his arrangement of figures in dense crowds or sparse groups, but in the individual features of each person portrayed, whether in *The Wedding Feast* (*pls 76-8*), *The Adoration of the Magi* (*pls 36-7*), *The Parable of the Blind* (*pls 67-9*) or *The Land of Cockaigne* (*pls 64-5*). While in some works there is an element of amused irony in the representation of characters and setting, in *The Adoration of the Magi* it is human evil that is revealed, with profound psychological understanding, in the expressions of the onlookers. In *The Land of Cockaigne* the figures, lost in a rhythm of total surrender to pleasure, seem closer to death than to life; in a different way, the figures in *The Parable of the Blind* move awkwardly across a landscape that is still and idyllic, unaware of their existence, so that here too we are reminded of death.

Bruegel's art developed between 1553 and his death in 1569. The problem of understanding and interpreting it is increased, particularly in the works of his last ten years, by his determination to do new things in art, from the

moment when he saw and set forth nature and human life differently from his predecessors. Of course he drew upon a wide range of experience; from his artistic milieu and travels as a young man to his study of his own country, he saw much and developed greatly in response to the world around him It was a world in which he could ponder the difference between a stable, traditional society and one in the throes of the Reformation, where fierce struggles stemmed from cruel tyranny.

With the intention of showing how 'human nature' reveals itself, and always from personal experience, Bruegel began the *Netherlandish Proverbs* (*pls 11-13*): the composition is a profound study of humanity, where space and landscape are treated in a manner no less profound. Leonardo's experience and observation of nature — its valleys, mountains, gorges, mysterious caverns and rocks — not only led him to 'research' in his mind into the problem of geology, but filled him with 'awe' as he contemplated the splendours of nature's vastness, which opened his mind to new perspectives and an awareness of a new relationship between man and nature. In his drawings the human figure is no longer made to fit into a theoretically preordained space, but is 'discovered' by Leonardo's experience in the measurement of 'distances' and the appearance of shadows as the light vibrates over them. His observations extend to the relationship between colour and light and shade under the varying effects of 'universal light' and 'reflected light'. Bruegel was not led to theorize in this way; but he too had acquired a profound and direct experience of nature in his journey to France and Italy, and in many respects his drawing is similar in feeling to that of Leonardo. Some of his sketches, as we noted, show an amazing awareness of geological structure. In the development of his painting as well, especially in *The Conversion of St Paul* (*pls 61-3*) it is obvious that the lingering memory of high mountains and steep river valleys provides a grandiose setting to the action. While in the *St Paul* scene the relationship between figures and rocky landscape is intimate, in *Hunters in the Snow* (*pl. 39*) the mountains form a distant backdrop to a vast panorama. And where in *The*

*Conversion of St Paul* the balance was between highlights and shadows, in *Hunters in the Snow* — it has been suggested by Faggin — the balance is tonal. Bruegel is not only a great draughtsman but also a great colourist, when he creates subtle relationships of tonalities in a chromatic rendering of light reflected by colour, or when 'his is local colour, differentiating objects by their quality of being red or blue or yellow, without taking account of the variations which may be contained in these colours through their presence in a space filled with light' (Argan, *op. cit.*). To illustrate this one may instance two paintings which are very different from each other in both inspiration and technique: *The Magpie on the Gallows* (*pls 70-1*) and *The Wedding Feast* (*pls 76-8*).

Fritz Grossmann, in *Pieter Bruegel. The Paintings* (London, Vol. I, 1955), has rightly pointed out that the nature of the man and the artist is complex and 'the apparent contradictions mirror the different aspects of an inexhaustibly rich personality'. We must therefore be particularly careful not to form a judgment that is too narrow or categorical if we are to understand his work fully.

Bruegel's clear vision of reality undoubtedly brought him close to the thought of Erasmus of Rotterdam (expressed in *In Praise of Folly*, the *Adages* and the *Colloquies*), whose view of the absurdity of the world, the foibles of human nature, and an existence of which we usually see only the appearance or pretence, coincided with Bruegel's own. Such paintings as *The Land of Cockaigne* (*pls 64-5*) or *The Adoration of the Magi* (*pls 36-7*) spring to mind in this connection. In the latter work it is the pharisaical or evil side of man's nature that is portrayed; in the former Bruegel satirizes his compatriots, sunken in a stupor of idleness and self-indulgence. This condition of ignorant helplessness is symbolized also in *The Parable of the Blind* (*pls 67-9*).

Bruegel's treatment of landscape is always worthy of attention. The background scene in *The Parable of the Blind*, with its distant vistas, may derive from the early Venetian Renaissance, but in its pictorial technique and poetic sensitivity it seems also to anticipate the first period

of Turner's landscape art. This anticipation can be seen to a more marked degree in the background of *The Peasant and the Bird-Nester* (*pl. 72*) and the distant expanses of *Storm at Sea* (*pl. 79*). Here the subtle treatment of line and the light touches of colour, the soft, delicate tinges of pink and the tenuous greens rising towards the white clouds which float gently in the blue sky, embody the impressionistic relationship between line and colour which was to become typical of Turner's mature period.

This strange and extraordinary artist, able to turn all his powers of concentration inward upon himself as if in a state of dream, never loses his awareness of life and death; at times the two are intermingled in a monstrous frenzy, through a symbol-laden realism which is close to Bosch, as in the '*Dulle Griet*' (*pl. 29*); while in *The Triumph of Death* (*pls 26-8*) it is death which in an apocalyptic appearance conquers life, allowing no possibility of escape. We have now reached the last period of Bruegel's activity, 1565-9, the time of the battles of the iconoclasts and the Spanish atrocities. Bruegel portrays these tragic events with a power of vision which rivals Bosch and an intense realism which goes beyond the older master. Looking at the effects of the brutal political régime in control of the Netherlands, Bruegel thinks of the pitiful condition of his coutry's humble peasants, whose ignorance makes them vulnerable and defenceless. He looks at them with a subtle and pungent — though not sarcastic — wit in *The Peasant Dance* (*pls 74-5*). In *The Cripples* (*pl. 73*) Bruegel shows humanity in a state of rebellion social, and perhaps political as well. In *The Wedding Feast* (*pls 76-8*), on the other hand, we see humanity at peace, in leisurely or vivacious motion. One of the basic problems for Bruegel was how, in his compositions, to make a synthesis between the actual event depicted and his positive or negative reaction to it. This synthesis is achieved to a certain extent in his early works. The scene in *Netherlandish Proverbs* (*pls 11-13*) is still overcrowded with figures and has allegorical overtones; his intuition told him it must be viewed from above. A similar compositional device can be seen in *The Fight between Carnival and Lent* (*pls 14-16*). In Bruegel's grandiose vision

of *The Tower of Babel* (*pl. 30*) the tower, at the centre of the composition, is given scale and volume by being set against the low, bare landscape while lies spread out at its feet. In *The Adoration of the Magi* (*pl. 36*) the small number of figures on whom the artist's attention is concentrated stand in a precise relationship to the group of the Virgin and Child and to the tightly-knit space; the fact that the composition is vertical rather than horizontal has led scholars to link it with Italian painting, particularly with the work of Parmigianino. Light is used most effectively as a medium of expression in *Christ and the Woman Taken in Adultery* (1565, London, Seilern coll.) and here again, though for different reasons, there are interesting points in common with the Italian artists whose works had served as models for the engravings of Pieter Coecke and Bernard van Orley.

In 1565, an *annus mirabilis* for his artistic production, Bruegel achieved a miraculous relationship between vast expanses of space and the light which bathes them, through the use of particular colour tones among which whites and greys predominate, as we saw in connection with *Hunters in the Snow* (*pls 38-9*). In this year also he painted *The Gloomy Day* (*pls 40-1*) where cold light is reflected from the disturbing landscape while the lower and central areas of the composition are dominated by tones of red; the distant view, formed by a strongly expressive rhythmic line and a powerful use of brushstrokes, is in its vibrant luminosity undoubtedly superior to the landscapes of Patenier. Bruegel's treatment of space, together with his way of opening out the composition towards the light and organizing his characters into significant groups, can be seen again in an astonishing example which foreshadows English eighteenth-century landscape painting: *The Corn Harvest* (*pls 44-5*). With its 'vision of distant landscapes' *The Return of the Herd* (*pls 46-7*) reveals the influence of Patenier, while *Winter Landscape with Skaters and a Bird-Trap* (1565, Brussels, Delaporte coll.) and *The Numbering at Bethlehem* (*pls 48-51*) are works in which subtle relationships of light bring out the Flemish character of the architectural setting and the landscape.

Reference has been made to the great degree of depth and intensity attained by Bruegel's composition in such works as *The Conversion of St Paul* (*pls 61-3*), *The Land of Cockaigne* (*pls 64-5*), *The Parable of the Blind* (*pls 67-9*), *The Triumph of Death* (*pls 26-8*) and *The Wedding Feast* (*pls 76-8*). When we consider these works in all their variety, we cannot but take heed of Grossmann's warning that Bruegel's personality must not be 'constrained' by a too narrow definition. The current of his thought was complex. He observed the people of his time in their dramatic and peaceful moments, their existence rooted in the twin realities of life and death — death which waits silently or with terrifying presence. Bruegel meditated deeply upon these matters and expressed them courageously and with great vision, so that his work has that universal quality which all can recognize. If he refused to portray humanity according to some ideal of formal beauty or in the light of a religious view of the universe, this is because he penetrated to the inner being of man and discovered its essential reality. His way was not to muse upon this inner reality through depths of colour turning to light, as Rembrandt did, but by precise observation and sensitive perception to convey it in the form of a direct emotion, in its most remote origins or as it comes closest to the very existence of man. And the setting of this human comedy is nature, in which he notes the restless ferment of spring, the clear light of a hard winter, the calm expanses of plains bathed in sunlight and the tragic, desolate void which, yet again, is an interpretation of space in relation to a reality. Thus Bruegel created a precise and irrevocable image of the existence of man as he stands at the threshold of death in the inner world of his own awareness.

# Bruegel and the critics

Some of the earliest biographical sources include L. Guic-
ciardini, *Descrittione di tutti Paesi Bassi, altrimenti detti
Germania Inferiore* (Antwerp 1567); G. Vasari, *Le Vite*
(Florence 1568, Vol. I and II; many English translations);
D. Lampsonius, *Pictorum aliquot celebrium germaniae
inferioris effigies* (Antwerp 1572); 'Lettre du Prévôt Mo-
rillon de 1572' in *Correspondance du Cardinal de Gran-
velle*, ed. C. Piot (Brussels 1877-94); Carel van Mander,
*Het Schilder-Boeck* (Haarlem 1604; French translation
Paris 1884; English translation New York 1936); 'Lettre
de Jean Bruegel au Cardinal Frédéric Borromée du 6 mars
1609' in G. Crivelli, *Giovanni Brueghel, pittor fiammingo*
(Milan 1868).

The work of Pieter Bruegel has been the subject of a
vast body of critical writing since the middle years of the
sixteenth century. Abraham Ortelius, in *Album amicorum*
(MS in Pembroke College, Cambridge), described him as
'not the painter of painters, but the nature of painters',
meaning to praise Bruegel's truth to nature; and if Ortelius
found that 'in all his works there is always more thought
than painting' this because by the term 'painting' he meant
the work of those artists who 'wish to add thereto some
sort of graceful elegance... which causes them to deviate
from true beauty: our Bruegel is free of this reproach.'
Niclaes Jonghlenck owned sixteen of the artist's paintings
in 1566; after the sack of Malines, Granvelle reported in
1572 that it was difficult to find any works by this
erstwhile famous artist. Although in 1568 Vasari described
Bruegel as an 'excellent master', only a year earlier Guic-
ciardini had referred to him as a 'great imitator of the
skill and fantasy of Hieronymus Bosch'. Lampsonius made
the same accusation in 1572. When Bruegel worked as
an engraver for Cock the resemblance of his work to that
of Bosch was commented upon. But not all critics dwelt
on the influence of Bosch, and Bruegel's love of the direct
sensations of nature together with his powerful imagination

caused him to be described as 'sharp and witty, the enduring glory of the Netherlands... who composed his landscapes with sureness of hand and wielded his brush with precise mastery, especially in the many small landscapes painted from life.' In 1648 the poet Robert Herrick in *To his Nephew, to be prosperous in the Art of Painting* put the name of Bruegel beside those of Raphael, Holbein and Rubens. That Rubens was himself an enthusiastic collector of Bruegel's work appears from the inventory made of his collection at Antwerp in 1640 (Kupferstichkabinett, Dresden).

At the end of the eighteenth century Sir Joshua Reynolds in *Journey to Flanders and Holland* (1797) praised Bruegel for the power of imagination revealed in *The Massacre of the Innocents*: 'there is here a great quantity of thinking, a representation of a variety of distress, enough for twenty modern.' And this praise was given in spite of the strange view he held that 'this painter was totally ignorant of all the mechanical art of making a picture.' In contrast, J. B. Descamps had written in *La Vie des peintres flamands, allemands et hollandois* (Paris 1753-63) that 'his compositions are very well thought out, the drawing is correct, the clothes of good quality, the hands expressive of their spiritual value.' The *Abecedario* of P. J. Mariette, written about 1760 though not published until 1851-60, includes the statement that 'Bruegel... has become famous not only for his burlesque compositions, but also for the excellent quality of his landscapes.'

Charles Baudelaire, in articles written in 1857 and 1858 (reprinted in his *Curiosités esthétiques*, Paris 1868), condemned the contemporary view that Bruegel's art consisted of 'fantasies and capriccios': to him Bruegel's work could only be explained by 'a kind of special, satanic grace'. In *Le Musée d'Anvers* (1862), Bürger-Thoré described Bruegel as 'a genuine master, insufficiently appreciated'. Later in the nineteenth century, G. F. Waagen in his *Handbook of Painting* (London 1869) expressed a low opinion of Bruegel's art; while in his *Biographie nationale* (1872) A. Siret revealed a narrow and insensitive view: 'a most interesting painter to study because all the

virtues and defects of the rustic school, of which he is in effect the head, are found in him'. By the end of the century this attitude was changing, and Henri Hymans, in 'Pierre Bruegel le Vieux' (*Gazette des Beaux-Arts*, 1890) realized that what must be seen in Bruegel is 'an artistic personality far superior to one merely preoccupied with the comic or even the unexpected'.

It was only at the beginning of the present century that writers started to devote serious study to Bruegel's art. After Berthold Riehl's *Geschichte des Sittenbildes in der deutschen Kunst bis zum Tode Pieter Brueghels des Älteren* (Berlin 1884), whose far-seeing judgment placed Bruegel far above his contemporaries, there was a gap of twenty years before the catalogue of the artist's works was published by Axel L. Romdahl ('Pieter Brueghel der Ältere und sein Kunstschaffen', in *Jahrbuch der Kunsthistorischen Sammlungen des Allerhöchsten Kaiserhauses*, Vienna 1904-5), and before René van Bastelaer and Georges Hulin de Loo, in *Peter Bruegel l'ancien, son œuvre et son temps* (Brussels 1907) adopted a rigorous scientific approach to the problem. There follows a bibliography of the most important critical writings published during the last seventy years, together with quotations from some of those works to give the reader an idea of their great variety.

Emile Michel, whose work on Bruegel began in the last years of the nineteenth century with *Les Bruegel* (Paris 1892), continued his study in *Les Maîtres du paysage* (Paris 1906). Van Bastelaer examined the engravings in *Les Estampes de Peter Bruegel l'Ancien* (Brussels 1908), and later wrote of the drawings in *Les Dessins de Peter Bruegel l'Ancien apppartenant au Cabinet des Estampes de la Bibliothèque Royale de Belgique* (Brussels 1924). He divides Bruegel's work into two periods. In the earlier period, 'not having had the misfortune to lose, through a conventional upbringing, the ideas among which his artistic vocation was formed... Bruegel unscrupulously subordinated form to essentials, and kept it closely linked to its original expressive function; and unlike Italianate painters, he refused to strive perpetually after formal beauty, preferring instead force of expression and of character. Being

indifferent to the graceful arrangement of groups, he placed the most diverse faces side by side in his compositions in an entirely natural manner. Thus by the logical effect of a stubborn ingenuity he brought together in the works of the first part of his career subjects and methods which are essentially popular by their nature.' In the second period of Bruegel's activity, on the other hand, Van Bastelaer saw in him 'an innate gift for style, not for that style consisting of pretentions to elegance and noble attitudes which was so rapidly to become a mannerism with Bartholomaeus Spranger', but the capacity to follow 'new paths' in composition, to give up 'his encyclopaedic superabundance and his tendency to bring people together in masses, so as to infuse the greatest force of expression into smaller groups and, in the end, individuals... In his final compositions he thus came to merge the two genres in harmonious work where the natural background... is viewed only as it relates to humanity.'

It is easy to find flaws in Van Bastelaer's argument, especially concerning the early works, but his discussions provided a starting point for many writers on Bruegel in this century, whether they agreed with his views or not.

Max J. Friedländer wrote in *Von Eyck bis Bruegel* (Berlin 1915; English translation 1956) that at a time when 'painters such as Floris and Coxie were beginning to dominate the scene' what was 'genuine' in Bruegel was that 'his art lacked the grand style, lacked Roman erudition.' And he went on to say: 'There was in Bruegel, in addition to his delight in direct observation of nature, in addition to his bent for story-telling, also defiant craving for novelty. Suspicious of every formula, of all ceremonial... the master liked nothing better than to peer ever closer into what was sacred, until the human and commonplace core was exposed... Compelled by the overflowing richness of his own ideas he had no time to work at the details... He became an impressionist as a result of his own temperament.' The last point was taken up again by Friedländer himself in *Peter Bruegel* (Berlin 1921) and in Vol. XIV of *Die altniederländische Malerei* (Berlin 1924-37).

In *Pieter Bruegel der Ältere* (Vienna 1921) and *Kunst-*

*geschichte als Geistesgeschichte* (Munich 1924), Max Dvořák stressed the point that 'it is certainly a mistake to consider Bruegel as simply a follower of Bosch... In Bosch there are still present a mediaeval demonology and the representation by symbols of occult forces... whereas Bruegel's interest lies in observing and describing the manifestation of life'. Dvořák considered that Bruegel penetrated deeply into the essence of both nature and man, examining man's life in relation to the physical and social conditions which surround it; and he praised the 'bravery with which the artist was able to forge ahead in only a few years, drawing new consequences from his new conception as he proceeded from work to work'.

Writing in *Bruegel* (Paris 1931), Edouard Michel concluded that 'his origins, his background, his perceptive view of humanity, his sense of the tragic and his originality, make him an artist who is Flemish to the marrow of his bones; but a Flemish artist who, in order to express himself, to give form to what he felt to be truly great and universal, learned much from Italy.'

In the section of this book devoted to Bruegel's works, a passage was quoted from Charles de Tolnay's *Pierre Bruegel l'Ancien* (Brussels 1935) in which the author emphasized the profound differences between the character of Bosch and that of Bruegel. We shall again be indebted, in the Notes on the Plates, to his perceptive examination of Bruegel's paintings and the various phases of his activity. Problems of a similar nature are treated by L. Maeterlinck in *Nederlandsche Spreekwoorden handelend voorgesteld door Pieter Bruegel den Oude* (Ghent 1903), and *Le Genre satirique dans la peinture flamande* (Ghent and Antwerp 1903).

Major contributions to Bruegel studies this century have come from Gustav Glück. After a discussion of Bruegel's pictures in the Kunsthistorisches Museum, Vienna (1910) he published *Bruegel Gemälde* (Vienna 1932). In *Bilder aus Bruegels Bildern* (Vienna 1936) his text accompanied reproductions of Bruegel's major paintings, including details; the plates were republished, with an introduction by Max Dvořák, in *Die Gemälde Pieter Bruegels* (Vienna 1941).

*Das grosse Bruegel-Werk* (Vienna 1951; English translation *Peter Brueghel the Elder*, New York and London 1951) contains the same plates with text taken from Glück's two books of the 1930s. Among many interesting observations, Glück suggests that 'the fact that Bruegel is so close to our sensibility, to our hearts, may be because he lived during a time of upheaval, when values were overturned, and because in his art there is already a presentiment of something we feel today.'

Another writer who has contributed a great deal to the interpretation and dating of Bruegel's pictures is Robert Genaille: *Bruegel l'ancien* (Paris 1953) and *La Peinture aux anciens Pays-Bas* (1954; English translation *Flemish Painting from Van Eyck to Bruegel*, London 1956). According to him the artist was 'especially a follower of Erasmus, though interested less in the labours of Erasmus over the texts of Cicero or St Jerome than in his more popular writings: *In Praise of Folly*, the *Adages*, the *Colloquies* and certainly also the *Institution of the Christian Principle* and *Querela Pacis*. It might be said that what struck Bruegel particularly in the thought of Erasmus was what could be related to popular Flemish literature, old mediaeval ideas and the platonic myth of the cavern: the idea of the absurdity of the world, the weaknesses of human nature, and an existence of which we usually see only the appearance or pretence, as in a scene from a play.'

Valentin Denis, in *Tutta la pittura di Pieter Bruegel* (Milan 1952), makes an observation that is astonishing coming from a scholar who has studied all of the artist's work: 'Like Rabelais and Shakespeare, Bruegel ingenuously made his own a rather pretentious fashion of his time, namely an over-pedantic display of culture, camouflaged under entirely innocent appearances.' Again, writing on the subject of the 'popular aspect' of Bruegel's art, Denis asserts that it is this which has value, since 'it is from this world of workers, and especially of peasants, that the marked male and female types are drawn.'

An invaluable work, often referred to in the present text, is *Bruegel* by Giuseppe Faggin (Milan 1953).

Some very interesting points were raised by G. C. Argan in 'Cultura e realismo in Pieter Bruegel' (*Letteratura*, 1955). He considers that Dvořák was the first writer to perceive the many facets of Bruegel's personality and of 'his culture, which in some respects is closely linked to the ideas and achievements of Italy, and in others is in sharp contrast to them. In actual fact, Bruegel is the only artist who, at the height of the sixteenth century, was able to put forward an alternative to the ideal of formal beauty which the Italians had founded on the logical certainty of a theory and the historical authority of the ancients...'. Bruegel 'rejected the devout, so his painting did not become religious, but secular; it is thus easy to conclude that while he was striving after the same truths as Michelangelo, he started out from opposite criteria. *Reculant pour mieux sauter*, Bruegel returned to a direct contact with Hieronymus Bosch, in exactly the same way as the youthful Michelangelo eagerly turned back to the primary sources of the Florentine renaissance — Donatello and Brunelleschi — ... Naturalism was rejected for two opposed reasons: idealism in the case of Michelangelo, realism in the case of Bruegel.' Argan also has interesting things to say on Bruegel's pictorial technique: 'his colour is that local colour which differentiates objects by their quality of being red or blue or yellow, without taking account of the variations which may affect these colours when they are seen in a space filled with light; but these local colours are later tempered by gradations of tones, and become interspersed with greys and browns, and every note of colour contains within itself a presentiment of the following as well as the power to reverberate through remote distances. The method of composition resembles fade-outs, where every image is produced, stands out clearly from the next and takes its place, finally eclipsing it from the viewpoint of the observer.'

Fritz Grossmann is a specialist on Bruegel's paintings, and *Pieter Bruegel. The Paintings* (London, Vol. I 1955) is an important contribution, since in it he has interpreted and dated each of the paintings. He also has a perceptive grasp of Bruegel's complex personality, and in his discussion

of the views expressed by earlier or contemporary writers he always insists that one must guard against too narrow definitions, such as 'the follower of Bosch or the last of the Primitives, a Mannerist in contact with Italian art, an illustrator, a genre painter, a landscape artist, a realist... a Libertine, a humanist, a laughing and a pessimist philosopher...' — and especially that the peasant background of Bruegel must be seen as a myth.

In *La pittura fiamminga* (1958), Salvini writes: 'the universality of one of Raphael's compositions derives from the blending of a number of harmonious details, whereas the spatial and vital universality of a painting by Bruegel is created out of the unification of a set of contrasts and dissonances'. Bruegel's personality is 'one of the most complex in the whole history of art... The drama rooted in a profound pessimism, which laughter and irony are not sufficient to conceal from us, explains both the disconcerting ideological content of his works, and the rigorous perfection of form in which his ideas are expressed each time, so that a thought which is complex or perhaps obscure becomes translated into the most crystalline poetry.' The past ten years have produced interesting developments in the critical study of Bruegel's work. For example Leo van Puyvelde, in *La Peinture flamande au siècle de Bosch et Breughel* (Paris 1962), considers the ideas and cultural background of Bruegel in relation to Erasmus, Thomas More and Rabelais, and finds that 'the plasticity of Bruegel is closer to life' than that of Bosch. Georges Marlier, in *Le Siècle de Bruegel* (1963), returns to the question of the relationship between Bruegel and the humanists of his time; he examines the extent of Patenier's influence and the degree of Bruegel's superiority over his predecessors, due to his grandiose vision of nature and the way he places living creatures in it. 'From his rustic visions and didactic pictures is distilled a wisdom which, while drawing on popular sources, rises to the serene and stoical contemplation of a Montaigne.'

According to Arnold Hauser in *Der Manierismus* (Munich 1964; English translation London 1965), 'one of the most conspicuous features of Bruegel's mannerism is his sub-

mergence of the individual in the mass or in nature.'
Bruegel was probably aware of the contemporary theory
of *docta ignorantia*, according to which man is ignorant
of his role in life, and even of his reality, 'and in his
paintings showing aspects of life that had become automatic
and mechanical — its games, masquerades, proverbs —
he seems to have been trying to express by their absurdity
and senselessness the enigmatic nature of the whole of
human existence.'

Marcel Brion in *L'Oeil, l'esprit et la main du peintre* (1966)
writes that Bruegel's world 'would be a secularized nature
if it did not retain a powerful mysterious reality, suggesting
the presence of the invisible behind the visible'. On the
question of technique, however, Brion goes so far as to
call Bruegel a 'descriptive' artist, and to say that the spirit
of his landscapes peopled by 'peasants crushed by sorrow
and toil' makes him in some ways a precursor of Millet.

In addition to the works already mentioned, Erwin
Panofsky's basic *Early Netherlandish Painting* (Cambridge,
Mass. and Oxford 1953) is essential reading. Bruegel's
'critical fortune' during the last few years may be followed
in the catalogue of the 1965 Brussels exhibition, *Le Siècle
de Bruegel*.

# Notes on the Plates

**1-3  View of Naples, c. 1558-63.** Oil on panel, 39.8×69.5 cm. Rome, Galleria Doria. Referred to in the inventories of Granvelle and Rubens. The attribution to Bruegel is accepted by most scholars, wtih the exception of Michel, who believes it to be by an imitator who was responsible also for *The Fall of Icarus* and the *Netherlandish Proverbs* in Berlin. Friedländer dates it 1558 after a drawing of 1552, while Grossmann suggests 1562-3. Ludwig Burchard noticed the similarity between this subject and the engraving *Naval Battle at Messina* made by Frans Huys in 1561 after a drawing by Bruegel. The *View of Naples* is unquestionably from the hand of Bruegel, and shows a number of innovations, a more flowing style, more subtle colour, and a wealth of deep, transparent luminous tones. The landmarks of the city are easily identifiable, from the Castel Nuovo at the right of the semicircular jetty to the remains of the Castel dell'Uovo on the left; a naval battle is under way offshore, visible through thick clouds of smoke.

**4-5  Landscape with the Fall of Icarus.** Oil on canvas (transferred from panel), 73.5×112 cm. Brussels, Musées Royaux des Beaux-Arts de Belgique. This work came on to the London market in 1912 and may be the one catalogued in the Imperial Collection at Prague in 1621 as '*Eine Historia vom Dedalo und Icaro vom alten Prügl*'. Michel ascribes it to an imitator of Bruegel, and Glück considers that the authentic version is that in the D. M. van Buuren Collection, New York and Brussels (formerly in the J. Herbrand Collection, Paris); but most other scholars regard the Brussels version as an original work. Tolnay dates it as early as 1555, while W. Vanbeselaere (*Pieter Bruegel en het nederlandsche manierisme*, Tielt 1944) ascribes it to the late period in the artist's activity, and Genaille gives the date 1562-3 on the basis of a comparison between the light in this picture and that in a drawing in the Louvre, *Landscape with Rising Sun*, dated 1561.
The subject is generally thought to have come from Ovid's *Metamorphoses*, though Van Lennep regards it as a complex allusion to alchemy. With its amazing luminosity the painting may have its origin in the landscape art of Patenier; it is also a precursor of the broad expanses of light created by Turner. Bathed in this light, the landscape and the youthful figure of the sower assume a contemplative serenity, oblivious of the tragedy of the drowning Icarus.

**6  Head of an Old Man.** Oil on panel, diameter 18 cm. Bordeaux, Musée des Beaux-Arts. This seems to be one of a series of Seven Deadly Sins, four of which have disappeared; according to Collins it represents Envy. While the old man resembles a character in Bosch's Lisbon Triptych, the picture was attributed to Bruegel by

Marlier and others. The angle of the head and the knowing expression are reminiscent of a man seen in profile at the centre of the guests in *The Wedding Feast* (*pl. 76*).

**7-10  Twelve Flemish Proverbs, 1558.** Oil on panel, 74.5×98.4 cm. Antwerp, Museum Mayer van den Bergh. The set of paintings is inscribed: 15[5]8 BRVEGEL. J. de Coo has made a close study of the proverbs; he notes that a separate wooden panel has been used for each one, and that each proverb is illustrated by a single person; a general inscription appears at the top of the painting. This series, mentioned in the catalogue of the sale of the art collection of Nicolas Cheens (Antwerp, 1621) as the work of Bruegel, is not accepted as authentic by Tolnay, Burchard or Grossman, although most other scholars do accept it, including Friedländer, who regards it as a late work. Michel describes it as an important work, 'created out of the first rush of inspiration... the brushstrokes vigorous, the colour dense'.

**11-13  Netherlandish Proverbs, 1559.** Oil on panel, 117×163 cm. Berlin-Dahlem, Staatliche Museen. Signed and dated bottom right: BRVEGEL 1559 (altered from 1560). The authenticity of the work is accepted by all scholars except Michel, who favours a version in Antwerp. The Berlin version probably also came from Antwerp, and is that referred to in the 1668 inventory of the possessions of Peter Stevens, who owned eleven of Bruegel's paintings. The theme of the picture as a whole is 'the world upside down'. About 120 proverbs were analysed by Wilhelm Fraenger in *Der Bauern-bruegel und das deutsche Sprichwort* (Zürich, Munich and Leipzig 1923); more recently Jan Grauls published a perceptive commentary, *Volkstaal en Volksleven en het werk van Pieter Bruegel* (1957). The arrangement of the figures against a background of architecture and landscape would indicate that the work belongs to the first period of Bruegel's activity, and this is confirmed by the autograph date.

**14-16  The Fight between Carnival and Lent, 1559.** Oil on panel, 118×164.5 cm. Vienna, Kunsthistorisches Museum. Signed and dated bottom left: BRVEGEL 1559. The painting was mentioned by Van Mander and is recorded in the Antwerp inventories of Philips van Valckenisse (1614) and H. de Neyt (1642). It left the Vienna Schatzkammer in 1748 and reached Prague, then Graz, and in 1765 was again in Vienna.
The basic elements of the composition have been closely studied by Faggin: the scene is viewed from above, so that the spectator can see all its varied aspects at once; and while at first the individual details seem to be minutely analytical and descriptive, it becomes clear that they form part of a continuous narrative which is only apparently episodic. The artist's biting irony is everywhere, in the forceful expression of movement and powerful range of colours; the figures have independent life and are at the same time focussed

upon the struggle in the foreground between Carnival and Lent —
personifications themselves as vivid as the procession of female
bigots, the group of lame beggars, the activity round the fishmonger's
counter, and the many other vignettes of Flemish life which include
builders at work on houses and on the lower part of a church
(top right). Elements in the long architectural perspective may have
been derived from the perspective designs of the Italian architect
Serlio, known to Bruegel through Coecke's studies and engravings.
The animation and distortion of the figures recalls Bosch, but here
the symbolism takes on a more realistic and human form.

**17-19  Children's Games, 1560.** Oil on panel, 118×161 cm. Vienna,
Kunsthistorisches Museum. Signed and dated bottom right: BRVEGEL
1560. Hulin de Loo saw in this work an 'encyclopaedia of Flemish
children's games', and A. de Cock and J. Teirlinck have analysed
and identified the games in *Kinderspel en Kinderliest in Zuid-
Nederland*. Tolnay distinguished four groups of entertainments which
could be taken to represent the succession of the seasons. The
painting is mentioned by Van Mander and appears in the catalogue
of Chrétien de Michel dated 1784. The receding perspective and
elegant architectural forms are reminiscent of the engravings of
Serlio in Coecke's version. The lively rhythm and forceful colour
range used to depict the minute figures relate this painting more
closely to *The Fight between Carnival and Lent* (pls 14-16).

**20-21  The Suicide of Saul, 1562.** Oil on panel, 33.5×55 cm.
Vienna, Kunsthistorisches Museum. The inscription bottom left
includes not only Bruegel's signature but also the biblical passage
from which the subject is taken: SAVL · XXXI CAIT ... BRVEGEL · M
· CCCCC · LXII. In fact, the composition illustrates Chapter 13 of the
First Book of Samuel. Dvořák thinks that the landscape is a fantastic
impression of Bruegel's recollection of the Alps; the mountain
scenery certainly provides an effective background to the movement
of the army as it surges forward 'like swarms of locusts', not noticing
the deaths of the king and his shield-bearer. The scene is viewed
from above, in a faded light where tones of green predominate,
growing darker as the eye of the viewer is led towards the
hallucinatory vision of a dense cluster of lances pointing towards
the sky.

**22  Two Monkeys, 1562.** Oil on panel, 20×23 cm. Berlin-Dahlem,
Staatliche Museen. Signed and dated bottom left: BRVEGEL MDLXII.
The painting belonged to a member of the Russian nobility before
being sold in Paris to the Berlin Museum in 1931, and it seems
that it was once in the collection of Pieter Stevens in Antwerp.
Only Fierens doubts the authenticity of this fine work. Art historians
are agreed as to the excellence of the composition: through an arch
at the base of which two frightened monkeys are crouching in
chains, we see the river Scheldt and the outline of Antwerp in an

atmosphere bathed in delicate light. The subject may symbolize the servitude of Flanders under Spanish rule.

**23-25 The Fall of the Rebel Angels, 1562.** Oil on panel, 117×162 cm. Brussels, Musées Royaux des Beaux Arts de Belgique. Signed and dated bottom left: M · D · LXII BRVEGEL. The painting was purchased for the museum in 1846 and was first listed as a work by 'Hell Bruegel' and later ascribed to Bosch, until the signature of Bruegel was discovered under the frame. The same subject occurs in a triptych painted by Floris for Antwerp Cathedral in 1554, but Bruegel's composition is obviously anti-classical and in the Flemish tradition of Bosch. Bruegel's fresh approach to this tradition appears particularly in the great intensity of movement throughout the picture, centring on the figure of St Michael. The colour scale is also new, following a circular rhythm of pinks, blues and whites through a subtle range of tones—though Michel states that much of the brightness, especially in the two angels on the left and right of St Michael, is not original but due to careless restoration.

**26-28 The Triumph of Death, c. 1562-65.** Oil on panel, 117×162 cm. Madrid, Prado. This is probably the painting catalogued in the legacy of Philips van Valckenisse (Antwerp, 1614; see also *pls 14-16*) as '*Triumph van den Doot, van Bruegel*'. In 1714 it was listed in the collection of the palace of San Ildefonso; it reached the Prado in 1847. Its authenticity is not disputed, but there is some disagreement over the dating. Genaille believes that it cannot be dated earlier than 1562-3, though it may not be as late as 1565-6, suggested by Hulin de Loo, or 1566-9, Michel's dating.

For various reasons the painting appears to belong to the last period of Bruegel's activity. It is the mature fruit of a lifetime of profound meditation, whose pessimistic conclusion was surely justified by the battles of the iconoclasts and the reign of terror of the Duke of Alba. By now Bruegel was so much a master of his technique that he could treat this dramatic and metaphysical subject in a manner rivalling Bosch. He can even be said to have surpassed Bosch, since the most surrealistic and monstrous creatures of his imagination, the skeletons, express the presence of Death in a mounting crescendo of reality, as does the background of distantly smouldering fires, charred countryside and deserted moorland. The various episodes of the action are closely linked through the logical unity of the artists's thought, which analyses events critically and without pity. If we are overcome by a shudder of horror and dread, this is because the repertory of diabolism which stirs Bruegel's imagination and has its origin in his youthful experience of the work of Bosch, the master of hallucinatory visions, has here attained an extraordinary intensity of human expression. The animal irrationality latent in man bursts forth in this composition as the story unfolds, to overthrow the king in his regal trappings, the cardinal borne aloft by a skeleton wearing a hat just like his own, a pilgrim whose throat is cut by a skeleton like a wayside robber,

a knight beside a gaming table under which a fool rushes to hide, lovers immersed in the oblivion of their music, a woman surprised in her nakedness — a whole humanity trying feebly, though desperately, to escape the tragic toll of the bell on the ruined tower, truncated as if by a whirlwind. The fearsome figures of the skeletons armed with lance and scythe move forward in an advance nothing can withstand, to overrun and surround the miserable remnants of the world made by man. They capture him in their net as he seeks to flee, and crush him like an avalanche against which a terrified rider draws his sword in vain. The skeletons advance behind heavy cross-emblazoned shields which prove to be stone coffin-lids; it is the triumph announced in the Apocalypse. With no hope of escape, Life yields to the Kingdom of Death.

**29 'Dulle Griet' (Mad Meg), 1562-64.** Oil on panel, 115×161 cm. Antwerp, Museum Mayer van den Bergh. At the bottom left are traces of an almost illegible signature and a date which may be 1562, 1563 or 1564. According to Van Mander, the painting belonged to the Emperor Rudolph II. In the seventeenth century it is recorded in the catalogue of the Hradschin, Prague, after which it came into the possession of the Swedish collector Brogren, then was in the Christian Hammer Gallery, Stockholm; bought at an auction in Cologne in 1894 by Van den Bergh, on the advice of Friedländer. Dated 1562 by Jedlicka and Glück, 1564 by Hulin de Loo, Michel and Friedländer, and 1565-6 by Tolnay.

In some respects the composition resembles works produced at the same time as *The Triumph of Death*; the sexual symbolism and monstrous forms are closer to Bosch, though — as in *The Triumph of Death* — they are treated more realistically. This realism is mirrored in the animated crowd of women and even in the wild face of 'Dulle Griet' as she advances towards Hell. In the wake of her passing figure follow destruction and conflict: she is the armour-plated witch who strides aggressively among monsters, metamorphoses and tumults. Van Lennep interprets the composition as an allusion to alchemy, and Michel thinks it refers to the sufferings endured by the Netherlands.

**30-31 The Tower of Babel, 1563.** Oil on panel, 114×155 cm. Vienna, Kunsthistorisches Museum. Signed and dated bottom left: BRVEGEL · FE · M · CCCCC · LXIII. Van Mander states that the painting belonged to Rudolph II; in 1659 it was in the collection of Archduke Leopold Wilhelm; it is recorded in Chrétien de Michel's catalogue in 1784. From the inventory of Giulio Clovio it appears that Bruegel executed a small version of this work in Rome, and the subject occurs again, with some variations, in the Rotterdam *Tower of Babel*. Van Mander writes of the Vienna version that 'one can look into it from above'. There is probably an allusion to the Colosseum at Rome in the structure of the Tower with its tiers of arcades, partly cut away. Bruegel shows an amazing understanding of the technical details of building, and portrays them with great precision.

The painting is remarkable also for its evocation of the monumental grandeur of Nimrod's insane construction, in its relation to the surrounding space and the tiny buildings below. The Tower stands like a tortured mountain; its arches gape like empty eye-sockets.

**32  The Tower of Babel, c. 1563-67.** Oil on panel, 60×74.5 cm. Rotterdam, Museum Boymans-Van Beuningen. Doubts have been expressed as to the authenticity of this smaller version, but it is recorded in Van Mander as 'another painting of the same subject, but smaller'. On the back of the panel appear the arms of Elizabeth of Parma, wife of Philip V. While Jedlicka and Friedländer ascribe it to the same period as the larger version, Tolnay, Genaille, and Grossmann in a more recent study, give the later date of 1567. The inspiration in this version, which is given the finish of a miniature, lacks the grandeur and subtle realism of the larger work.

**33-35  The Procession to Calvary, 1564.** Oil on panel, 124×170 cm. Vienna, Kunsthistorisches Museum. Signed and dated bottom right: BRVEGEL M · D · LXIIII. In 1565 this work was in the collection of Niclaes Jonghelinck, and Van Mander states that it belonged to Rudolph II. It appears in the catalogue of the Geistliche Schatz-Kammer, Vienna, in 1748. The vast sense of space which this composition conveys contains nothing of the formal idealism of a Van der Weyden or a Memling, as Faggin has observed. There is a vigorous realism in the general conception: 'On the arid summit of Golgotha, the reds, dark browns and whites are arranged in a rhythm that follows the slight depression of the terrain and the steep ascent, which the pale light detaches against the more intense tones of the sky, to create a sense of fatal expectation.' When we consider that this painting contains more than five hundred figures, we can realize how far Bruegel carried out his intention of showing the indifference of this animated crowd towards the figure of Christ fallen under the weight of the cross. Among the scattered figures the eye is caught by the group in the foreground: here, in the holy women and St John, who comforts the Virgin, human grief is concentrated.

**36-37  The Adoration of the Magi, 1564.** Oil on panel, 108×87.5 cm. London, National Gallery. Signed and dated bottom right: BRVEGEL M · D · LXIIII. In a Viennese collection in 1890; acquired by George Roth, also of Vienna, who sold it to the museum in 1921. The vertical composition is rare among Bruegel's works, and seems to indicate that the painting was intended as an altarpiece. Some critics have seen in it the influence of Italian art; for example, the work of Parmigianino; Dvořák made a detailed study of the picture, and sees a similarity to the work of Correggio in its system of diagonals receding in depth. Tolnay sees the influence of Michelangelo's Bruges *Madonna* in the central figure of the Virgin holding the Child on her lap. The expressions of the people who surround the Virgin, startling in themselves, are portrayed with a fierce intensity of realism.

**38-39 Hunters in the Snow, 1565.** Oil on panel, 117×162 cm. Vienna, Kunsthistorisches Museum. Signed and dated bottom centre: BRVEGEL M · D · LXV. Included in the 1659 inventory of the collection of Archduke Leopold Wilhelm; mentioned in Chrétien de Michel's catalogue in 1784; remained in the Belvedere until the end of the eighteenth century.

The composition is remarkable for the three-dimensional treatment of space. As Faggin observes, the balance between shadow and light is here replaced by a tonal balance to suggest the cold, clear light of winter on the wide plains where, especially in the distance, shades of white predominate over the browns and greys and the tenuous pale green of the sky. Another remarkable feature of the composition is the skill with which its various elements are arranged. From the hilly slope in the foreground and on the left, where we see a few houses, some bare trees and the three hunters with their dogs, signs of life gradually become more and more sparse until there are only scattered villages and tiny figures dotted about in the distant landscape (here Bruegel must have been thinking of his travels in the Alps). Although these elements occur in a wide area, Bruegel's skill maintains the unity of the composition, so that his underlying theme is fully expressed; the presence of life - barely discernible in the silence and solitude of the hard winter, in the frost and pale light. The complete immobility of nature is broken only by the flight of a bird as it glides through the immensity of space, outlined against the distant mountains.

Glück has suggested that this illustrates January and February in a cycle of paintings of the seasons executed in 1565; it would be followed, in this cycle, by *The Gloomy Day* (March-April), *Haymaking* (May-June), *The Corn Harvest* (July-August), and *The Return of the Herd* (September-October). The final picture is lost.

**40-41 The Gloomy Day, 1565.** Oil on panel, 118×163 cm. Vienna, Kunsthistorisches Museum. Signed and dated bottom left: BRVEGEL MDLXV. Included in the 1659 inventory of the collection of Archduke Leopold Wilhelm. For a suggestion as to the season depicted, see the note on *pls 38-9*; other scholars differ from Glück. Bruegel was interested less in illustrating a particular month than in portraying that moment when the air grows dark at twilight and brings with it a vague sadness — a feeling he was so adept at expressing through his use of reddish tones set against a cold light over distant mountains and turbulent water — while a few peasants carry out their tasks in the recurrent rhythm of their lives. The landscape is reminiscent of Patenier, but here of course the intention is quite different, the imagination more forceful and the expression more inventive.

**42-43 Haymaking.** Oil on panel, 114×161 cm. Prague, National Gallery. Formerly in the collection of Princess Leopoldine Grassalkowitsch Esterhazy and of Prince Lobkowitz of Raudnitz. This is unanimously seen as an illustration of early summer (see *pls 38-9*,

note), and its clear atmosphere contrasts with the dark tones of *The Gloomy Day*. There is a feeling of serenity in the distant landscape; the three peasant women in the foreground and the basket carriers seem to move to the rhythm of a dance. The broad and varied landscape provides a lively background to the joyful animation of the scene, created in translucent tones and broad patches of colour.

**44-45   The Corn Harvest, 1565.** Oil on panel, 118×160.7 cm. New York, Metropolitan Museum of Art. Signed and dated bottom right: BRVEGEL LXV. Exhibited at the Belvedere in Vienna in 1784, according to Chrétien de Michel; taken to Paris by Napoleon in 1809; a century later purchased from Jean Doucet of Paris by P. J. Cels of Brussels, who sold it to the United States in 1912.
The season is high summer (see *pls 38-9*, note). Again small individual elements are brought together in a unified composition. The dominant colour tones are clear and luminous, and the yellow of the foreground in particular is a source of radiance which fills the spectator with the joy of sight, and illuminates the group of harvesters at their work or, lower right, eating and at rest. Details of the hazy, distant landscape, in their delicate colour tones and expressive draughtsmanship, suggest what was to be Turner's vision of nature.

**46-47   The Return of the Herd, 1565.** Oil on panel, 117×159 cm. Vienna, Kunsthistorisches Museum. Signed and dated bottom left: BRVEGEL MDLXV. Mentioned by Van Mander, and recorded in the 1659 inventory of Archduke Leopold Wilhelm. Michel points out that the picture is in a poor state of preservation, but in spite of this it is accepted by scholars as an important example of Bruegel's work. Dvořák finds it especially interesting for the ascending rhythm of the composition, along the line of herdsmen and animals, in an autumn landscape of light browns and greenish blues. (See also *pls 38-9*, note).

**48-51   The Numbering at Bethlehem, 1566.** Oil on panel, 116×164.5 cm. Brussels, Musées Royaux des Beaux-Arts de Belgique. Signed and dated bottom right: BRVEGEL 1566. In the Van Colen de Bouchet Collection, Antwerp, and later in the Huybrechts Collection. Purchased by the museum at an auction in 1902.
At first sight the story seems to unfold in a calm and serene mood, but when we look more closely into the details, we discover the secret suffering of these people, from those in the foreground to those in the farthest distance, as they move slowly, bowed under the weight of their burdens and numbed with cold. According to Michel the theme is 'human anguish before the menace of the unknown'. Faggin remarks on the 'sense of unease, of physical and moral disquiet' which runs throughout the picture. The text illustrated is St Luke 2:1-5: '... And all went to be taxed, every one to his own city. And Joseph also went up from Galilee, out of the city

of Nazareth, into Judaea, unto the city of David, which is called Bethlehem'. Bruegel has made all the characters his contemporaries; Bethlehem is a Flemish town. From the white surface of the snow which focusses attention on the relationship between the browns of the houses and the muted greens of the distant lake, to the sun setting low over the horizon, in a light without shadows or reflections, a leafless tree forms delicate arabesques with its bare branches, defenceless against the frost just as the people are defenceless against the society of their time.

**52-53  The Massacre of the Innocents, 1565-67.** Oil on panel, 111×160 cm. Vienna, Kunsthistorisches Museum. Signed but undated bottom right: BRVEG. Mentioned by Van Mander as in the collection of Rudolph II in Prague; in the Geistliche Schatzkammer, Vienna, in the eighteenth century.

The authenticity of this version has always been disputed. Grossmann believes that the picture in Hampton Court (in the English Royal Collection) is the authentic one, and considers it far superior to the Vienna version. Genaille, on the other hand, is certain that the Vienna version is authentic, and Faggin regards it as a highly important composition, praising the 'great dramatic power' with which the scene is set against 'a squalid winter landscape' which underlines the 'sufferings of a nation, bowed by the inclemency of nature and the violence of man.' The date 1565-66 is generally accepted, but R. L. Delevoy (*Bruegel*, 1955) dates it 1567 and sees in it a commentary on the violent régime of the Duke of Alba, which began in that year. The Spanish repression may indeed have inspired the realistic scene of peasants imploring a herald in the foreground, and the horsemen who appear throughout the picture wear the costume of Flemish soldiers in the service of Spain.

**54-55  The Sermon of St John the Baptist, 1566.** Oil on panel, 95×160.5 cm. Budapest, Szépmüveszeti Museum. Signed and dated bottom right: BRVEGEL · M · D · LXVI. Bequeathed to the museum by Count Ivan Batthyány. Most scholars regard this as authentic but Hulin de Loo suspects it. Tolnay sees a resemblance between this composition and one by the Monogrammist of Brunswick, a copy of which is to be seen in the Wicar Museum, Lille. In his catalogue Van Puyvelde includes the version in the collection of Vittorio Duca in Milan (signed and dated) which he considers superior to the Budapest version. Other versions, thought to be by Bruegel's sons, are in Antwerp (Koninklijk Museum), Munich (Alte Pinakothek), and Vaduz (Liechtenstein Gallery).

The composition is conceived in such a way that the crowd of people gathered around the Preacher convey a sense of movement and expectation which increases in an ascending rhythm up the slope of the hill. The sense of expectation among the bystanders, some of whom wear eastern dress, is not of a mystical character that would be outside the scope of Bruegel's art — but their astonishment and awe are expressed in a realistic manner. The distant landscape

glimpsed at the right includes Flemish features; its delicate luminosity is in sharp contrast to the robustly drawn tree trunks which frame the lively scene in the foreground.

**56-57   The Wedding Dance in the Open Air, 1566.** Oil on panel, 119×157 cm. Detroit, Institute of Arts. Dated bottom right: M · D · LXVI. Considered authentic by Valentiner, Genaille, Denis, Grossmann, Faggin and Friedländer, who sees in it an anticipation of Rubens' *Kermesse*. Michel and Hulin de Loo believe that the version in the Koninklijk Museum, Antwerp, is the original. There is another version in the Musée des Beaux Arts, Narbonne, while the example in the Staatliche Museen, Berlin-Dahlem is, according to Hulin de Loo, a copy by the artist's son Pieter. There are two other versions with the signature: P. BRUEGEL, one in the Morel Collection, Ghent, and the other in the Weber Collection, Hamburg. In connection with the Detroit version, it is important to remember the engraving by Pieter van der Heyden, published by Cock with the inscription: P. BRUEGEL INVENT. In the Detroit composition the realistic treatment of the gestures and facial expressions is very marked, and there is a subtle humour in the rhythm of the figures' movement.

**58-60   Wedding Procession.** Oil on panel, 68.5×114 cm. Brussels, Musée Municipal. Formerly in the Spencer Churchill Collection at Northwick Park, and catalogued in 1864 as the work of Bruegel the Elder; acquired by R. Finck of Brussels at an auction in London. The authorship of this painting has given rise to impassioned argument. Michel and Hulin de Loo do not accept it as the work of Bruegel; Tolnay ascribes it to Jan Bruegel (as he does *The Adoration of the Magi* in Brussels, which to the present writer seems to bear no relationship to the painting under discussion where the treatment is entirely different); while Friedländer, Borenius, Glück, Denis, Genaille and Marlier are entirely convinced of the painting's authenticity. Two processions of figures led by pipers — men following the groom, women and children following the bride — move across the open meadow, portrayed with a lively sense of narrative.

**61-63   The Conversion of St Paul, 1567.** Oil on panel, 108×156 cm. Vienna, Kunsthistorisches Museum. Signed and dated bottom right: BRVEGEL · M · LXVII. The painting was acquired in 1594 by Archduke Ernst, Governor of the Netherlands, was mentioned by Van Mander as in the collection of Rudolph II, and later appeared in the 1718 and 1737 inventories of the Hradschin at Prague. There is a drawing by Bruegel in the Louvre depicting an Alpine landscape which Denis has related to the artist's journey to Italy, and a similar landscape occurs in this painting on a more grandiose scale. The mounting rhythm of lights and darks which delineate the crags, strong dark shadows under jutting rocks and in the mountain gorges gradually becoming lighter as the eye travels upward, combines with

the slow and weary progress of the soldiers in the deep ravines to create a 'psychic representation' of the event. The meaning of this work, according to Roland Barthès (*Eléments de sémiologie,* Paris 1965), 'may be defined only within a process of signification, in a manner which is almost tautological: it is that "something" which the man who employs line means it to express.' It was not Bruegel's intention here to depict the conversion as a manifestation of Divine Grace, seen in a mystical light — as the Italian Renaissance might have suggested to him; instead, by placing the central theme in an unimportant position in the composition, he has created an overwhelming impression of the supremacy of nature and of the dense crowd, through whom one can scarcely glimpse the miracle.

**64-65 The Land of Cockaigne, 1567.** Oil on panel, 52×78 cm. Munich, Alte Pinakothek. Signed and dated bottom left: M · D · LXVII · BRVEGEL. Included in the inventories of the Prague Hradschin in 1621 and 1647-8. Removed during the siege of Prague, it entered the collection of Queen Christina of Sweden. Later owned by Henri Rossier de Vevey in Paris, who in 1901 sold it to Richard von Kaufman of Berlin. Bought at an auction by the museum.

The subject is the 'Luilekkerland' of popular Flemish tradition, a paradise of gluttony. The painting conveys an atmosphere of somnolence and total abandonment; all problems of human consciousness and reason have been cast aside by the three figures lying outsretched in a semicircle — the scholar with his books, the peasant with his flail, and the soldier. There are two interesting interpretations of this work which to a certain extent complement one another. According to Faggin, 'it is not improbable that Bruegel intended to allude to the utopian kingdoms which reformers and prophets were offering to all classes of society during those revolutionary times'. Maeterlinck sees the composition as a satire by Bruegel on his compatriots, who were especially fond of the pleasures of the table and of idleness, two vices which deprive man of his vigour and moral strength and prepare the way for oppression and tyranny.

In the year this picture was being painted, 1567, the despotic rule of the Duke of Alba began, and as his oppressive measures spread like a devouring flame, Bruegel may have wished to exhort his people to make some attempt at least to defend their rights to dignity and freedom. As an artist he conceived the composition in a bold and expressive rhythm following the pattern of a semicircle, almost a vortex, to express the total abandonment of the three figures in the foreground, who represent three clearly defined classes. The apparent calm is a complete hiatus in the rhythm of life, where man is indeed closer to death than he is to life, if by 'life' we mean that state in which consciousness is 'present', 'vigilant' and 'active'. Bruegel has included a symbol found also in Bosch: the egg walking on its own two legs, with a knife sticking out of the top, is a standard alchemical representation of one of Satan's minions. At the edge of the hillock on which the three

men lie outstretched, a pig, with a knife stuck in its side, walks along; while beneath a roof laden with pies a soldier, his only armour a helmet and gauntlets, stands about to swallow a bird that flies into his mouth.

**66  The Misanthrope, 1568.** Tempera on canvas, 86×85 cm. Naples, Museo Nazionale. Signed and dated on the frame, left: BRVEGEL, 1568. In the collection of Count Masi in Parma until it was confiscated by the Farnesi in 1611; in 1680 in the catalogue of the Palazzo Giardino, Parma; in 1734 acquired by the museum. In the lower part of the tondo can be seen the inscription: 'Om dat de Werelt is soe ongetru/Daer om gha ic in den ru' (because the world is so false I wear mourning). Most scholars accept this painting as authentic, but there is some disagreement about the date, even though the picture is dated: Romdhal thinks it should be 1563 and Michel, Hulin de Loo and Friedländer favour 1565. Friedländer thinks that the composition represents the last period of the artist's activity, when he could concentrate all his power of expression upon one monumental figure; a great advance over his early compositions which are crowded with figures, in a sort of *horror vacui.*
The subject has been variously interpreted: some critics think that the main figure represents Heresy, while others see in it the Misanthrope who leaves the world for a life of renunciation, but yet takes with him the purse which attracts the thief — portrayed within a cross-surmounted orb, the symbol of the world. The purse has the shape and colour of a heart, making us feel the bitterness of the lonely man's desolation. To Hulin de Loo the solitary figure in black suggests the carved mourners on Late Gothic tombs. While the presence of the cut-purse is at odds with the serenity of the background landscape, we must not therefore conclude that it is a later addition, as Michel has suggested: its relation to the other figure is too clear and deliberate, and furthermore precisely the same composition occurs in an engraving after a drawing attributed to Bruegel in the Masson Collection, Amiens. Moreover, if Bruegel had not included this pickpocket, so realistically drawn in his gesture and greedy expression, the whole balance of the composition would be lost; the figure of the Misanthrope is slightly to the left, whereas obviously if it were to stand alone the artist would have placed it at the centre. On the contrary, when one considers the painting in conjunction with the inscription at the bottom, which, scholars believe, was written by Bruegel himself, it becomes evident that by concentrating the composition upon these two sharply contrasted figures he expressed a profound personal thought and at the same time illustrated his chosen text.

**67-69  The Parable of the Blind, 1568.** Tempera on canvas, 86×154 cm. Naples, Museo Nazionale. Signed and dated bottom left: BRVE-GEL · M · D · LX · VIII. There is a drawing of two blind men by Bruegel dated 1562 in Berlin, and from this it appears that the

subject of this painting had been in his mind for some time. The theme is inspired by two passages from the Gospels: St Luke 6:39, 'Can the blind guide the blind? shall they not both fall into a pit?', and St Matthew 15:14, 'And if the blind guide the blind, both shall fall into a pit'. Dvořák points out the similarity between the landscape in this composition and landscapes of the early Venetian Renaissance; but one must always keep in mind the Flemish elements in Bruegel's art. The background is made up of delicate colour tones; with its church, whose tall steeple points towards the sky, and the delicate foliage of the trees through which the distant light gently shimmers, it conveys an atmosphere of serenity which contrasts with the anguished features of the blind men in the foreground. The diagonal leading downward and forward, through the rhythmic line which links the figures, concentrates the spectator's attention on the leader's fall, and gives it realistic weight; while the solitude of the figures in the landscape is more effective even than blindness in suggesting the presence of death, ignored by an idyllic nature.

**70-71   The Magpie on the Gallows, 1568.** Oil on panel, 45.9×50.8 cm. Darmstadt, Hessisches Landesmuseum. Signed and dated bottom left: BRVEGEL 1568. According to Van Mander, Bruegel means here that those who speak evil should be condemned to the gallows. In the centre of the composition and in an idyllic landscape stands the gallows with the magpie on it, while to the left peasants are dancing. Van Bastelaer sees in the theme a reference to the situation of the Netherlands, where all that seemed serene was potentially dangerous. Faggin interprets the subject as an allegory of the despotism of Philip II, which could never succeed in depriving the Flemish people of the sun or of the joy of living; and he sees the work as a triumph of light and air. Tolnay speaks of the paradisiac serenity of this composition bathed in light; Hulin de Loo describes it as a marvel of painting and of absolute unity of light; and Grossmann finds that its technique seems to anticipate the achievements of the nineteenth century. Gainsborough, in his landscapes painted about 1750, appears as an intermediary between Bruegel and the artists of the nineteenth century.

**72   The Peasant and the Bird-Nester, 1568.** Oil on panel, 59×68 cm. Vienna, Kunsthistorisches Museum. Signed and dated bottom left: BRVEGEL MD · LXVIII. Mentioned in the 1659 inventory of Archduke Leopold Wilhelm, removed to Paris at the time of Napoleon, and finally returned to Vienna.
Tolnay thought he saw a connection between the figure of the shepherd and Michelangelo's Christ in the *Last Judgment*; further, he suggests that the gesture of the figure's left arm is similar to that of the Infant Jesus in Michelangelo's Bruges *Madonna*. Surely this is taking comparisons too far, for the resemblances are unlikely to be more than coincidental. There is an intimate mood in this composition, where a young thief clings to a tree trunk in order

to rob a nest, while a shepherd stands by and, looking directly at the viewer, points to the bird-nester. The treatment of light and shade enhances this mood, moving from darker tones in the foreground to light colours in the distant landscape, where delicate tones of pink and tenuous green grade upward to white clouds and blue sky. An impressionistic relationship between brushstrokes and colour, such as we find in the works of Turner's mature period, is here anticipated.

**73 The Cripples, 1568.** Oil on panel, 18×21 cm. Paris, Louvre. Signed and dated bottom left: BRVEGEL M · D · LXVIII. The subject appears in the catalogue of the collection of Herman de Neyt compiled in 1624, and in other seventeenth-century collections in Antwerp; in 1650 it was in the inventory of Queen Christina, compiled by the Marquis de Fresne; in 1892 it was given to the Louvre by Paul Mantz. Two Flemish inscriptions have been deciphered on the back of this small panel, which translated read: 'O cripples, may your affairs prosper', and 'Not even nature possesses what our art lacks, so great is the privilege granted to the painter; here nature, translated into painted image and seen in her cripples, stands amazed on realizing that Bruegel is her equal.' Delevoy sees the theme as a political allusion to the classes of society, and thinks that the tails decorating the cripples' clothes are connected with the Gueux, or 'Beggars', a Dutch nationalist party opposed to Spanish rule whose badge was the foxtail; Tolnay reminds us that these tails weree adopted in order to ridicule the young Philip II and Granvelle. The gestures and grouping of the figures in their various positions, portrayed with uncompromising realism, are echoed by the relationship between the colours, which are vivid but not garish.

**74-75 The Peasant Dance, c. 1565-67.** Oil on panel, 114×164 cm. Vienna, Kunsthistorisches Museum. Signed bottom right: BRVEGEL. Mentioned in the Vienna inventories since the early seventeenth century; taken from the Weltliche Schatzkammer to the Imperial Gallery in 1748; removed to France, together with the *Wedding Feast*, during the Napoleonic period; finally restored to Vienna. The painting though signed, is undated, and it is generally believed to be a work of the last period of Bruegel's activity. Genaille and Jedlicka date it 1565-6, and Grossmann c. 1567. Van Mander tells of Bruegel's visits to peasant festivities, and it does seem that he is present in person here, and is closely studying the dancing couples. Their appearance, costumes and facial expressions, in the lively rhythm of their movements, seem to be brought close to us by the composition as if by the lens of a cine-camera. The objectivity which the artist attains with such conspicuous realism does not lie in superficial appearances, but in the inner core of these human beings, the peasants and countryfolk who have become 'characters' for him. They stand out against the low horizon, in a space which opens out like a circle in front of their houses

and shops. A subtle vein of irony colours the artist's view of this rustic *joie de vivre*.

**76-78  The Wedding Feast, 1566-69.** Oil on panel, 114 × 163 cm. Vienna, Kunsthistorisches Museum. The painting is unsigned, but is unanimously accepted as authentic. It appears in the 1594 inventory of Archduke Ernst of Austria, and in the 1659 inventory of Archduke Leopold Wilhelm. At the end of the eighteenth century it was in the Belvedere in Vienna, and after a short stay in Paris in the Napoleonic period it was returned to Vienna. Genaille dates the painting 1566, Grossmann c. 1567, and most other scholars favour 1568-9.

The picture is mentioned by Van Mander, and once again we are reminded of his account of Bruegel's visits to peasant gatherings. Here the peasants are at a banquet (laid in a barn to accommodate them all), surrounding the bride who sits enthroned at the centre. Faggin rightly points out that the peasants are not intended as the expression of any political view. The figure seen in profile at the far right-hand corner of the table may be a self-portrait of the artist (his features and non-rustic clothes suggest this); but whether or not that is the case we would argue that Bruegel's human presence in the composition is unquestionable, in the way he portrays this human scene in the gestures, movements and expressions of those taking part in it, but without any hint of caricature; instead, he interprets it as a reality in which he himself can participate with a keen sense of involvement.

The action and characters are drawn at the most telling moment: the bagpipe player with his humble, astonished gaze; the child sitting shyly apart; the young man carrying food seen from the back, a wooden spoon tucked into the brim of his hat; and an old man, who has endured much hardship, seen in profile as he looks up in wonder. Most admirable in the compositon is the diagonal which leads from the door towards the viewer, widening out as it reaches the centre of activity. Bruegel's expressiveness is not to be found in mere 'characterization', but in the act of drawing us close to the inner life of these people on a day when they can forget their toils. They are drawn to each other by their poverty and by the humble life they share. The colour tones of red, green, brown and white, set against the yellow of the tall haystacks (massed together to create a backcloth), show them to us vividly.

**79  Storm at Sea, c. 1566-69.** Oil on panel 70.3 × 97 cm. Vienna, Kunsthistorisches Museum. By its subject, this seems likely to be the picture referred to in the 1668 inventory of the possessions of Peter Stevens of Antwerp. Tolnay accepts it as an authentic work, but describes it as a sketch. Michel doubts its authenticity, and it has been attributed to Joos de Momper. However most other experts agree that it is by Bruegel, and that it belongs to the last phase of his activity. Tolnay dates it 1566-7, as does Genaille, while

Friedländer and Glück date it 1568, and Denis thinks it is Bruegel's last work, painted in 1569.

The painting is unusually expressive: in the midst of a great storm, one ship — on the left — is laying an oil-slick, while another — in the centre — casts out a barrel to distract the whale pursuing it (a traditional symbol for the man who is distracted from the good by trifles). In many ways the picture is close to Bruegel's early *View of Naples* (*pl. 1*), with its lively movement, its broad expanse of sea, its waves and sails swollen by the wind, and its rich colour tones with subtle transparent variations of light. It is a work of profound synthesis, created with vigorous brushstrokes; the strong colours in the foreground become dense at the horizon as they take on tones of violet and blue and a dull, reddish brown on which flecks of white indicate seagulls, flying the storm.

View of Naples 1558 - 63

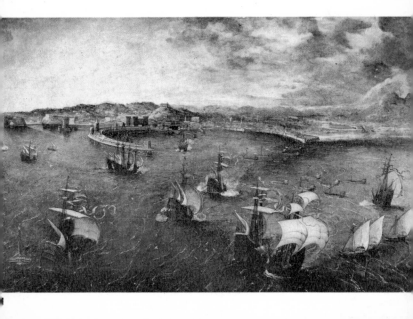

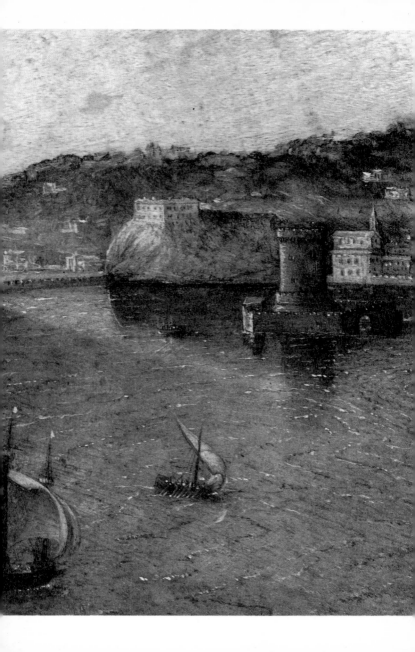

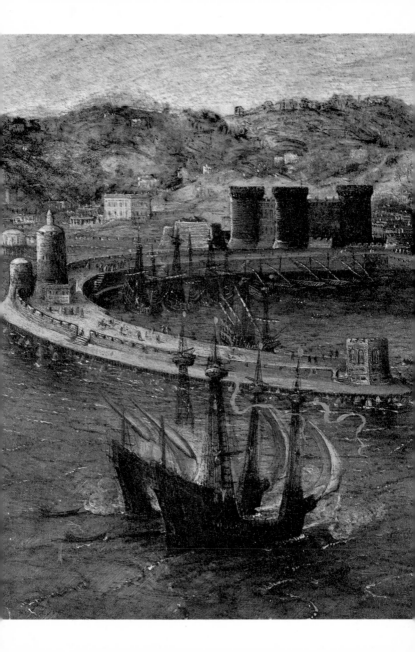

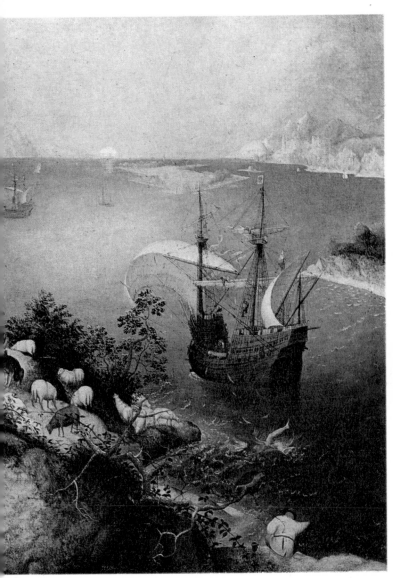

Head of an old man

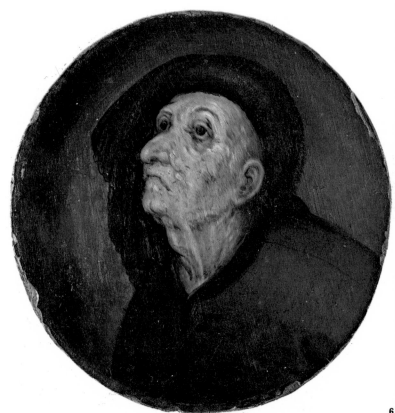

6

7

→ Netherlandish Proverbs
1559

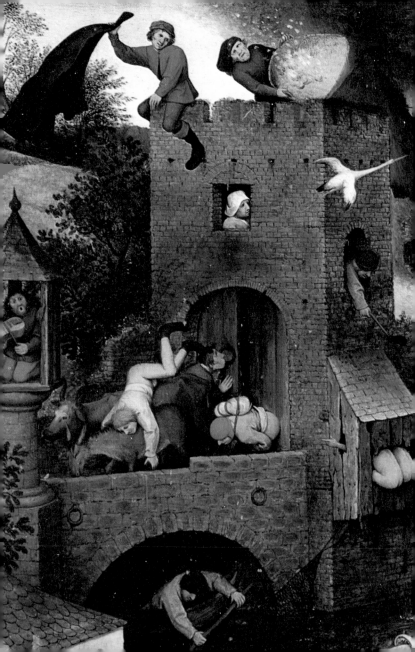

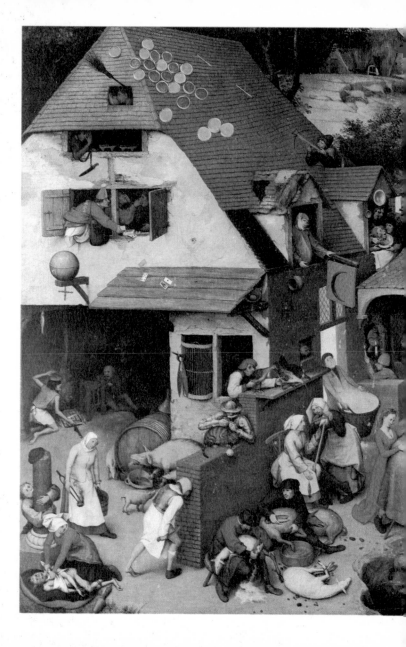

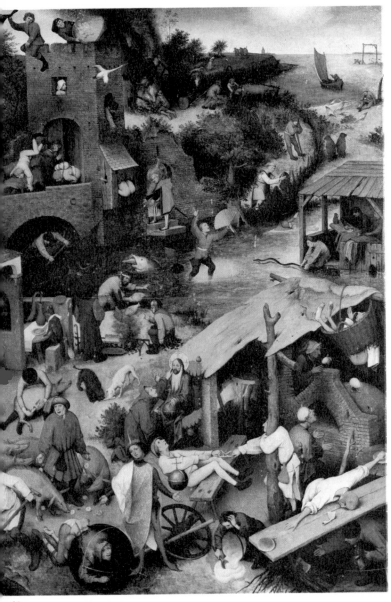

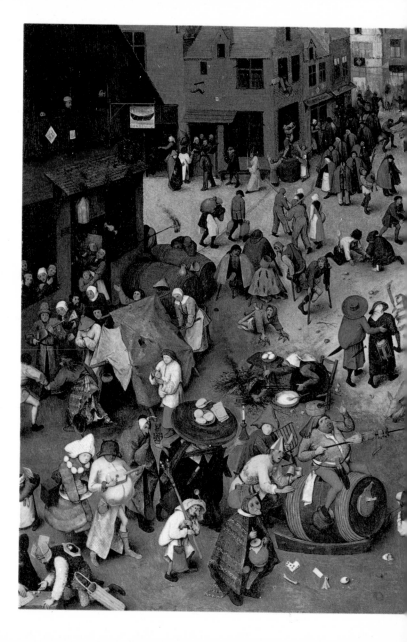

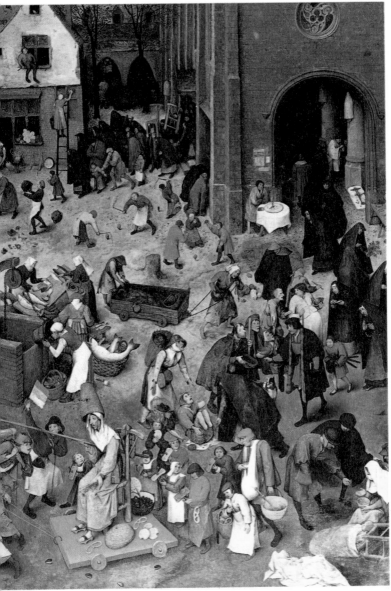

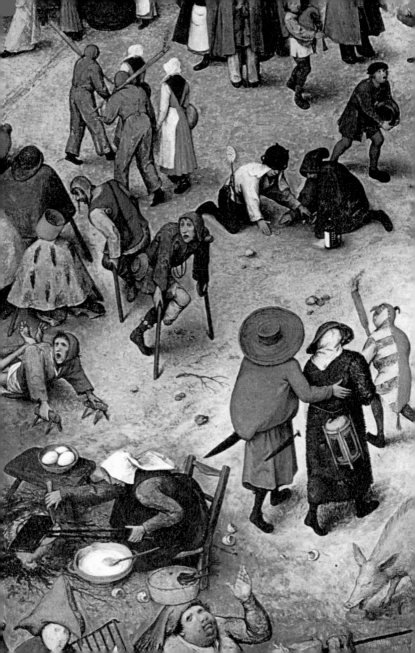

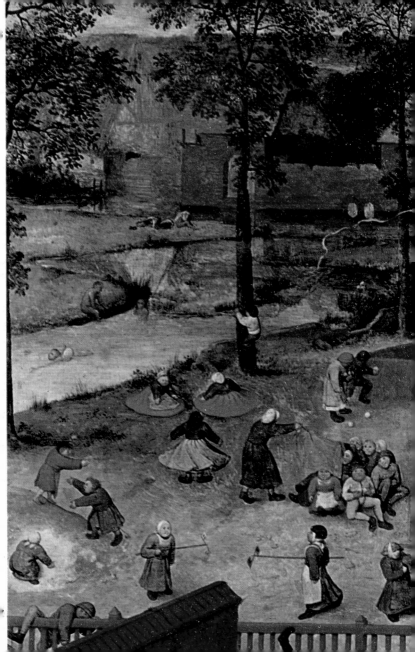

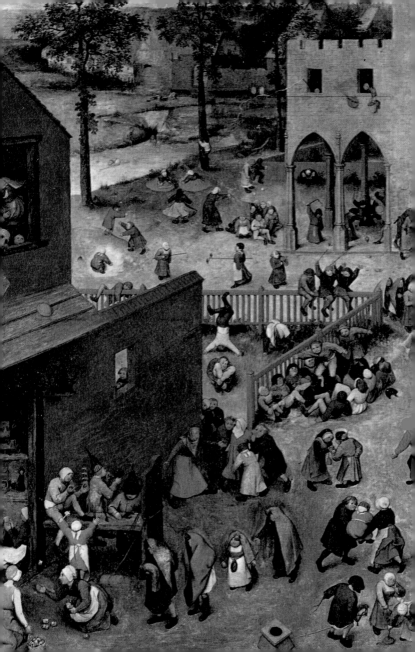

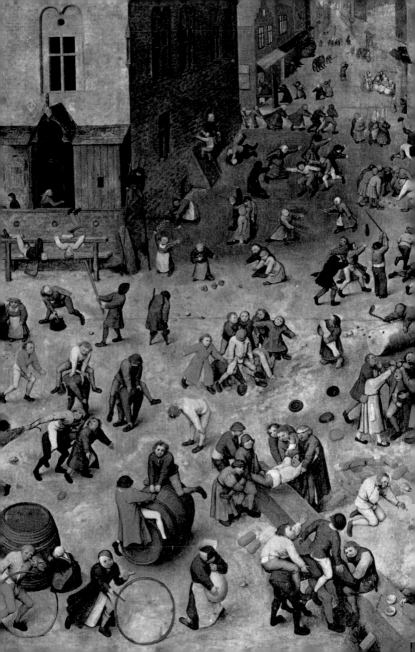

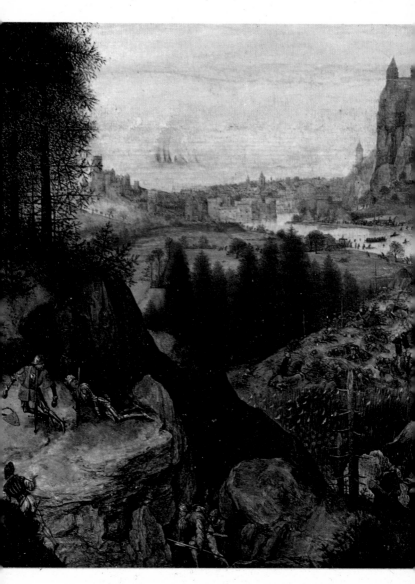

The Suicide of Saul 1562

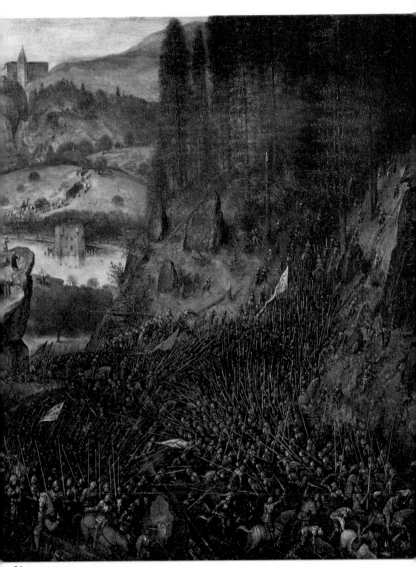

21

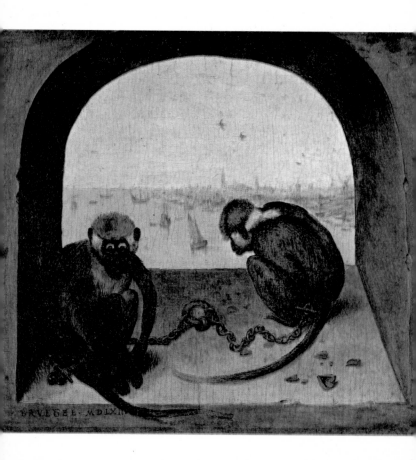

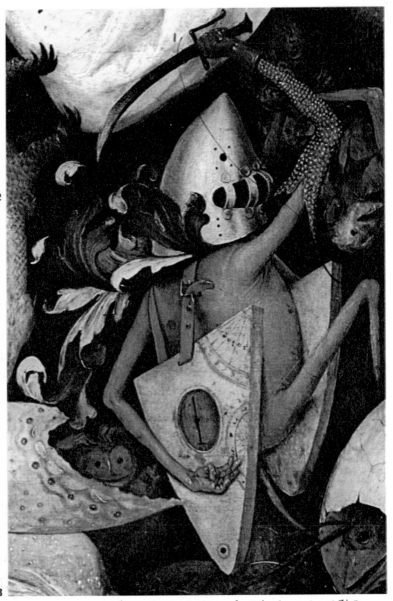

The Fall of the Rebel Angels 1562.

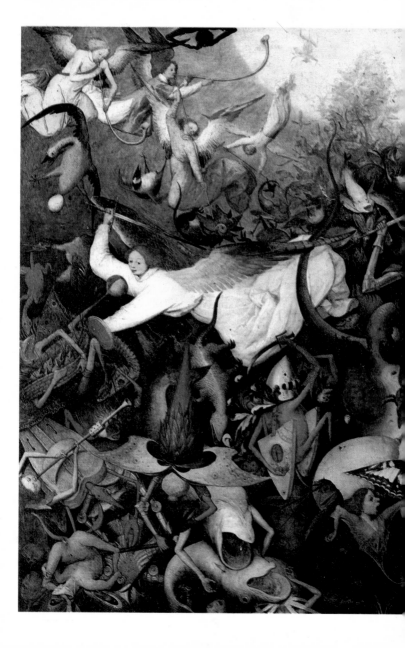

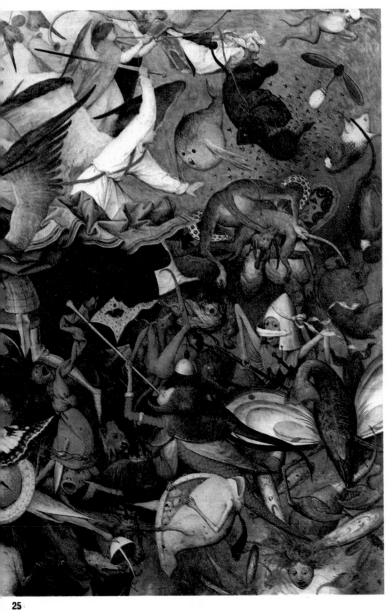

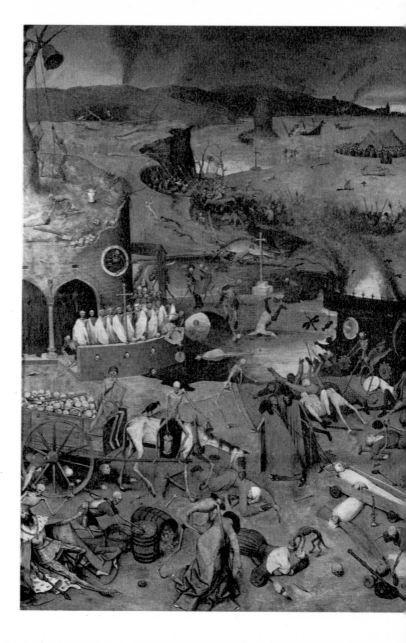

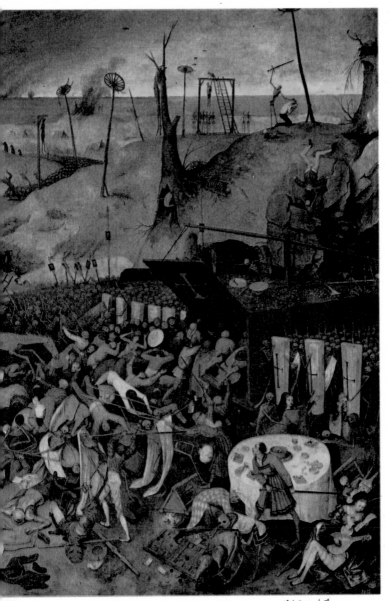

27          The Triumph of Death          1562-65

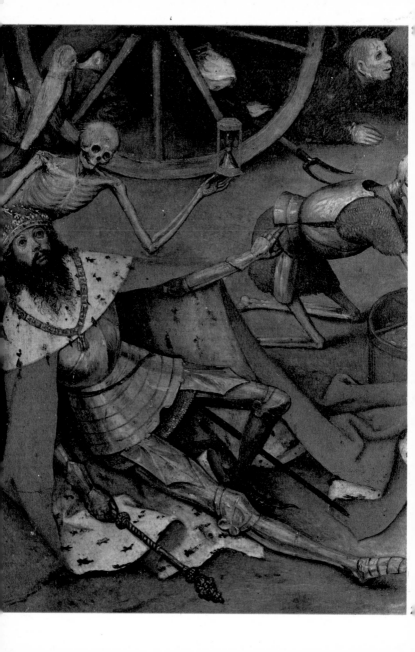

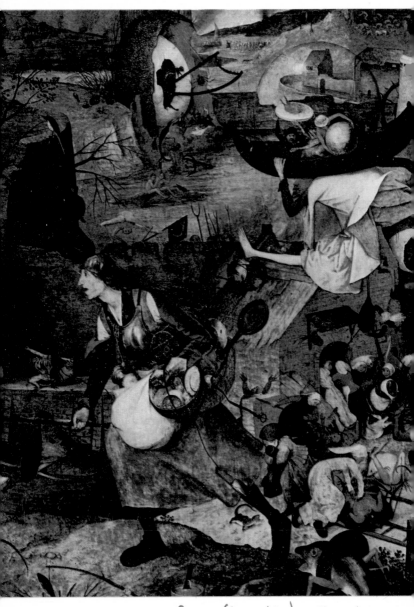

Dulle Griet (Mad Meg) 1562-64

The Tower of Babel 1563

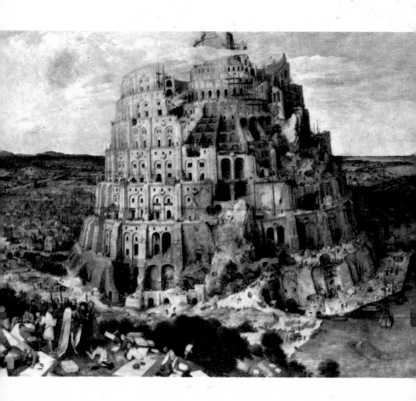

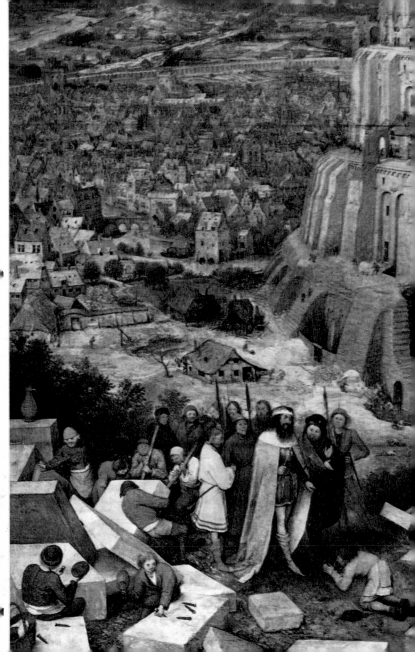

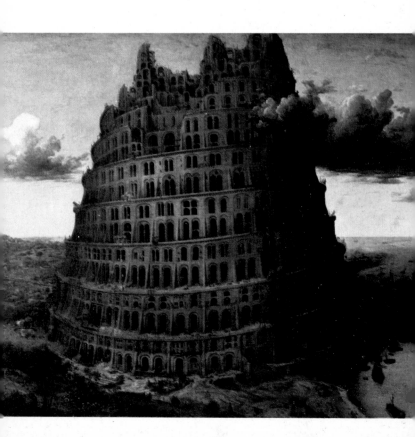

The Procession to Calvary 1564

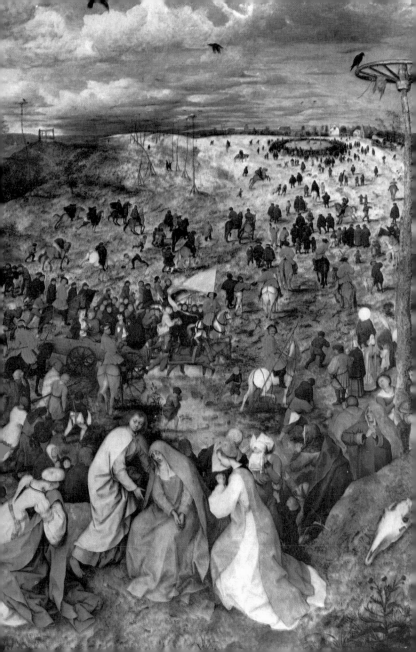

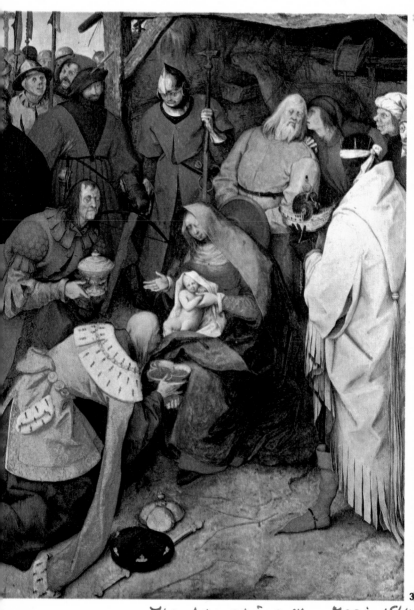

The Adoration of the Magi 1564

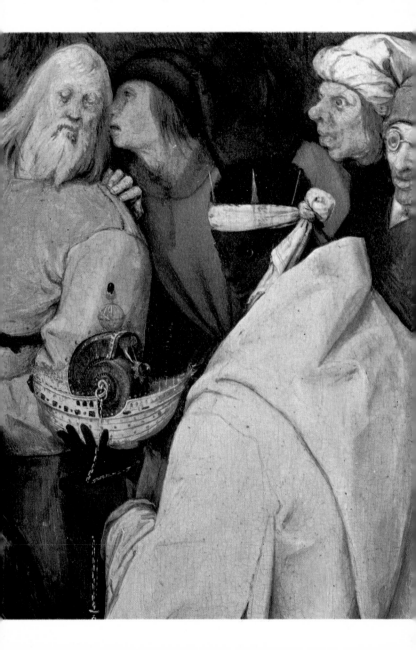

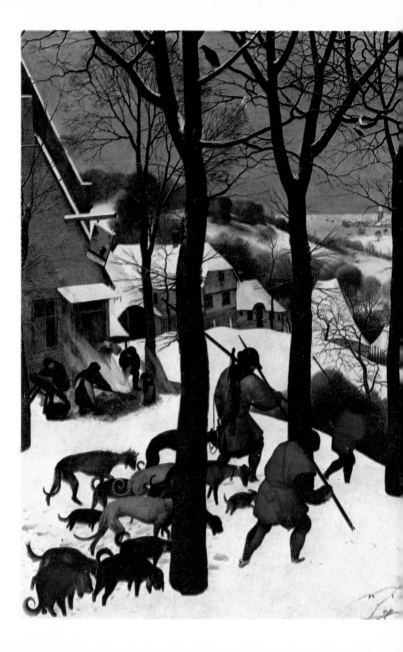

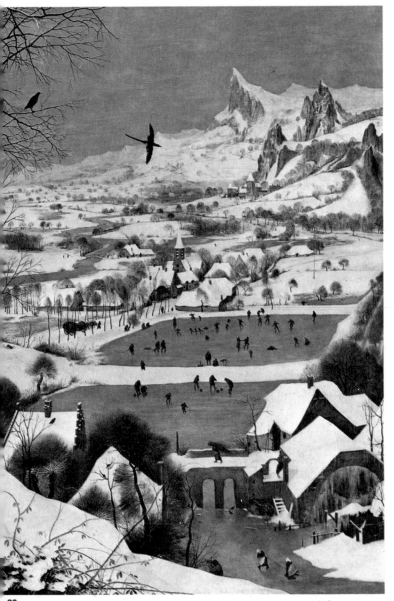

Hunters in the Snow 1565

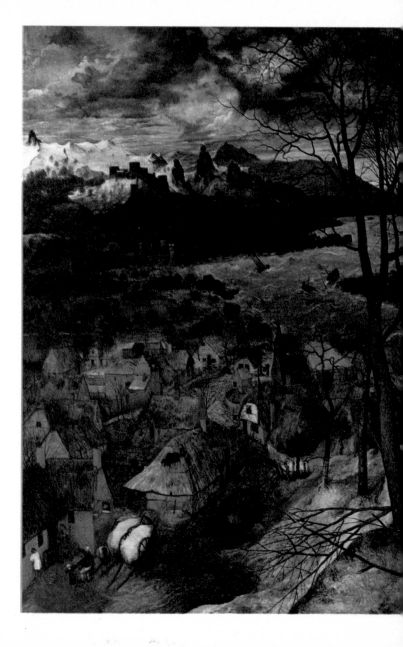

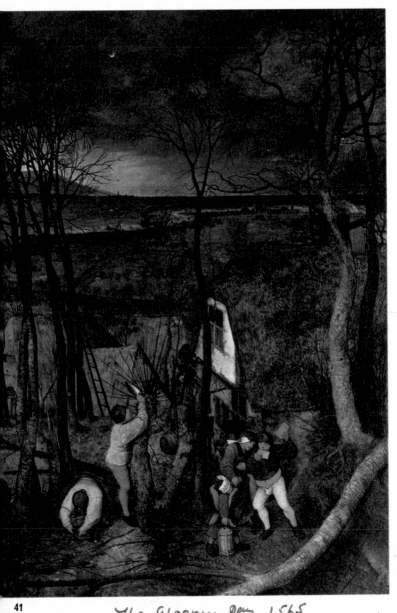

41    The Gloomy Day 1565

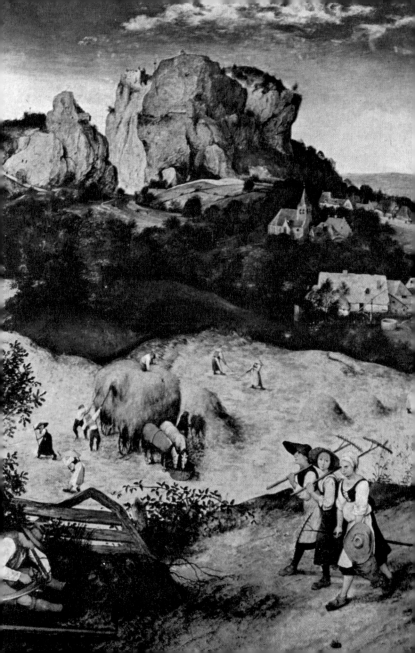

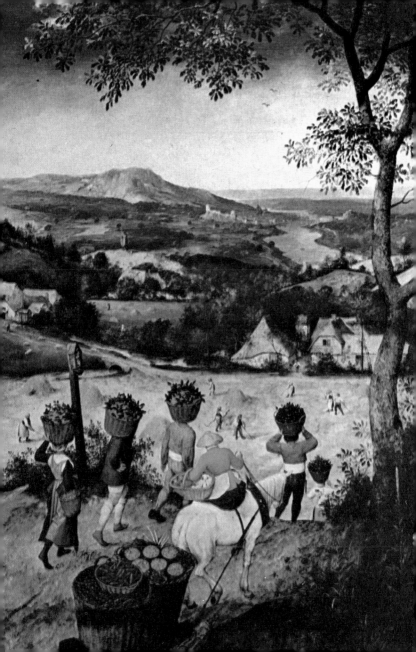

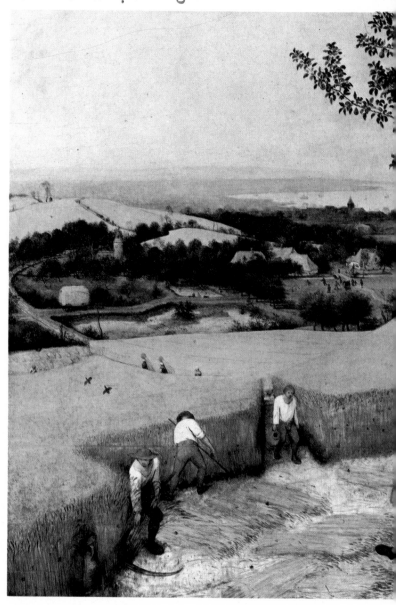

The Corn Harvest 1565

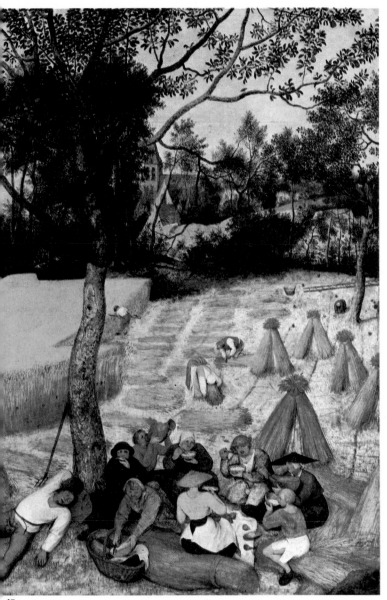

45

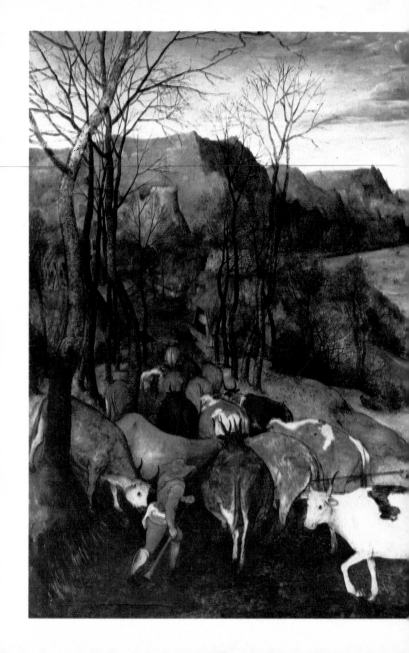

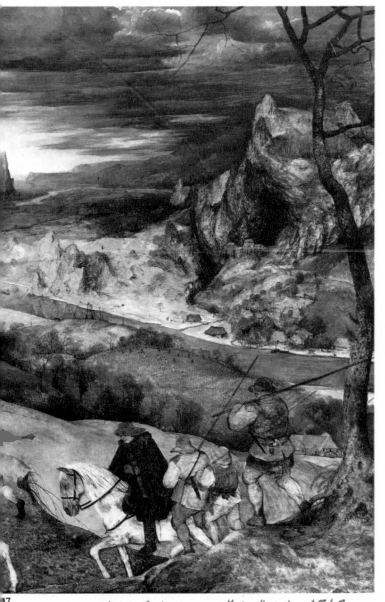

87  The Return of the Herd  1565

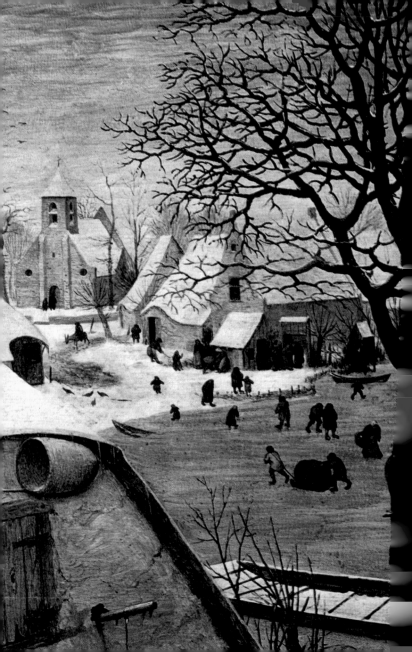

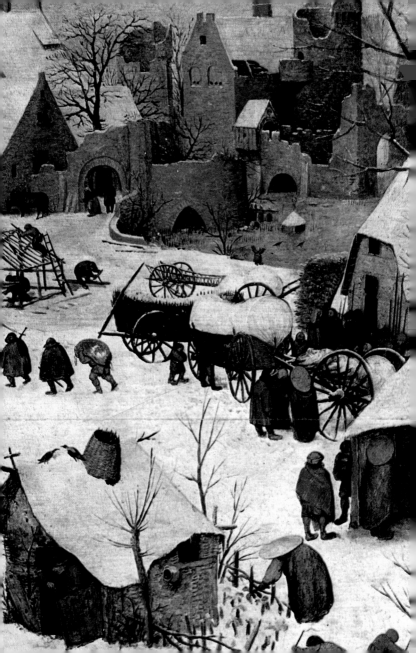

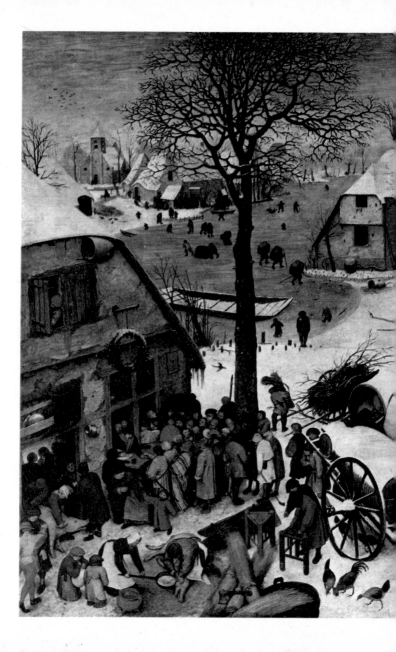

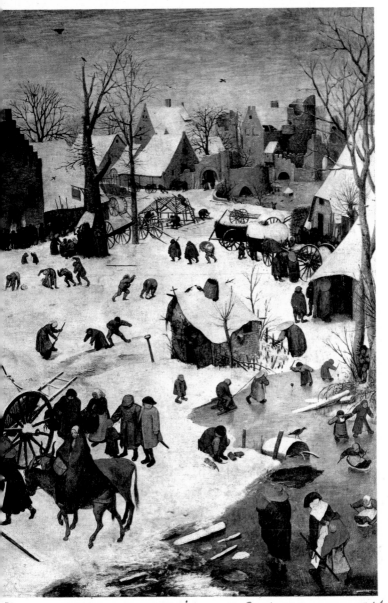

The Numbering at Bethlehem 1566

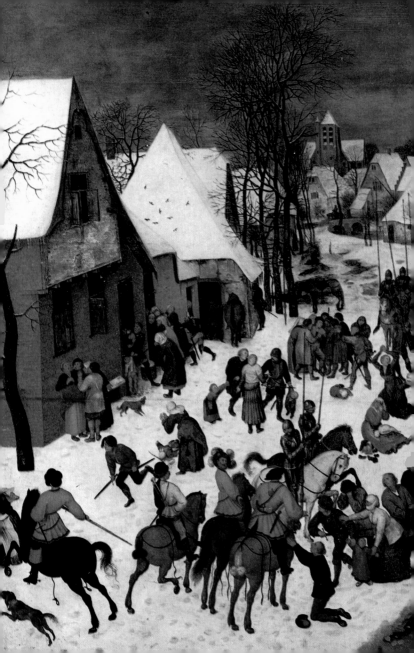

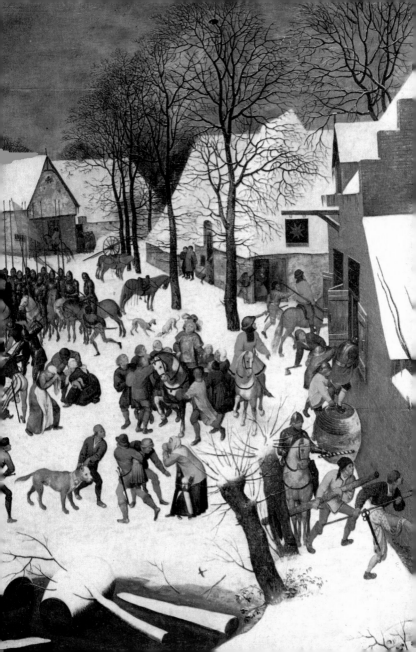

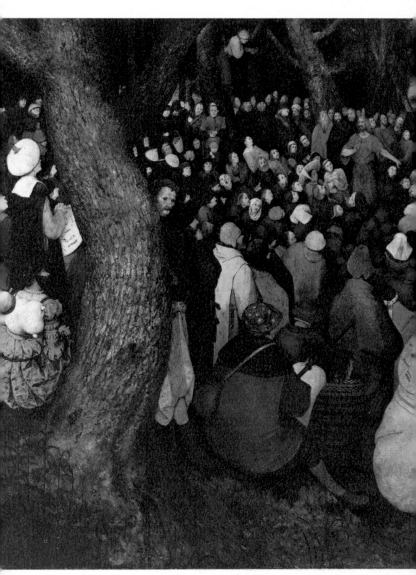

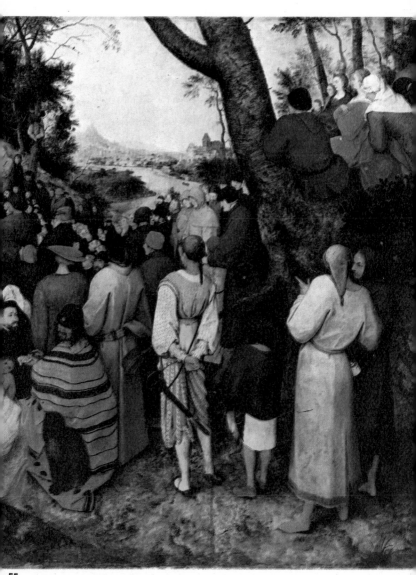

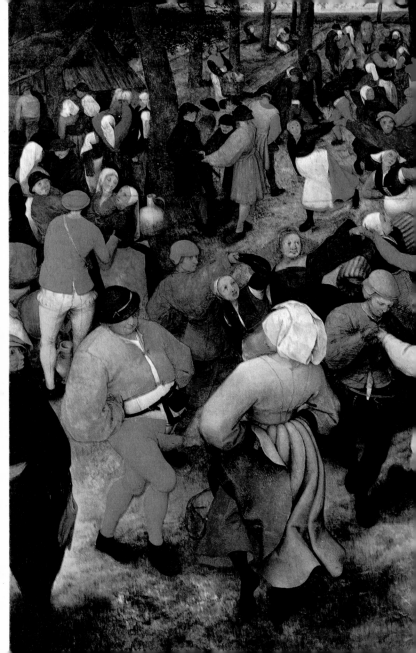

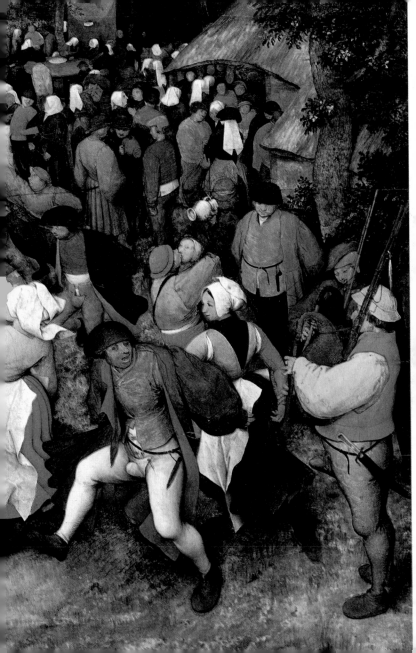

The Wedding Dance i the open air
1566

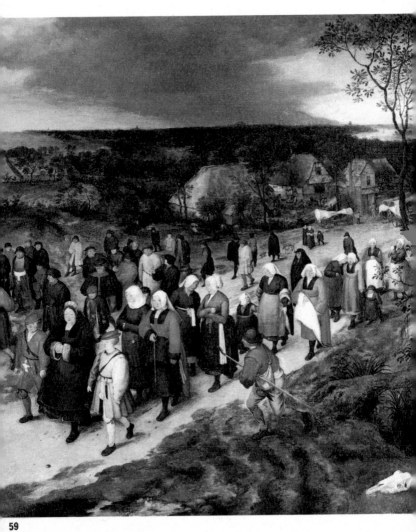

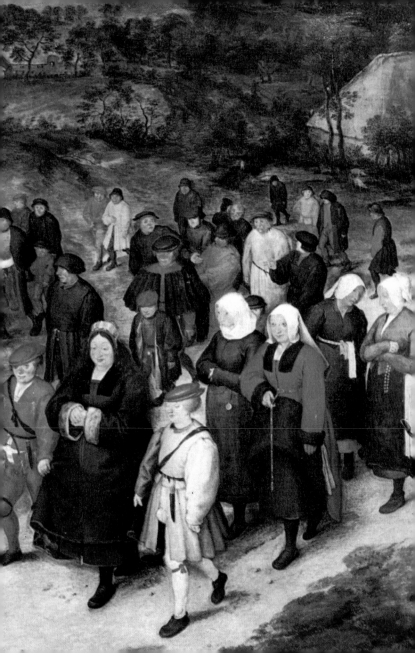

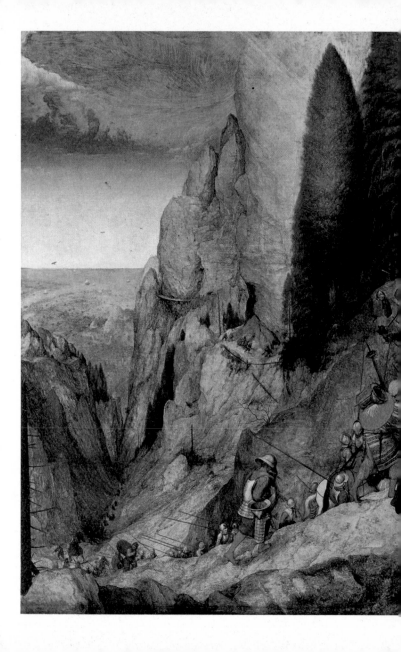

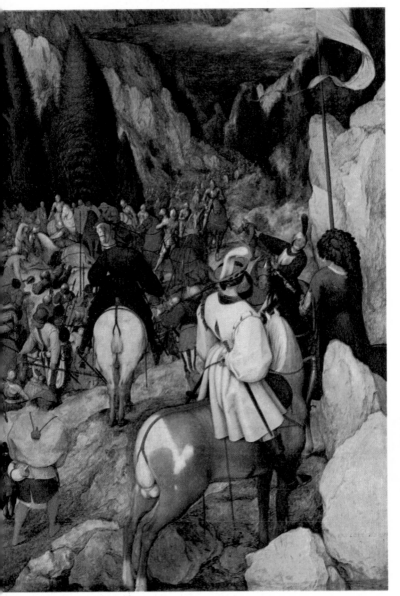

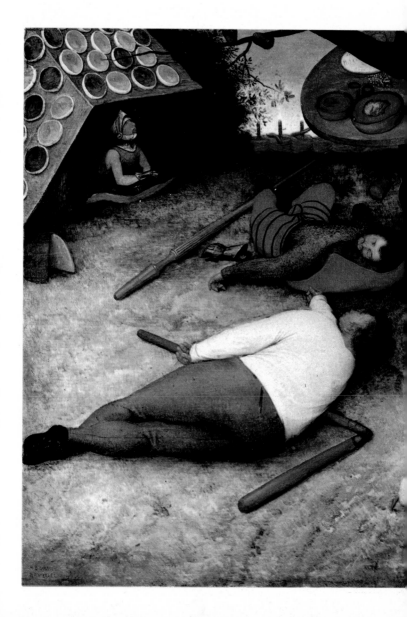

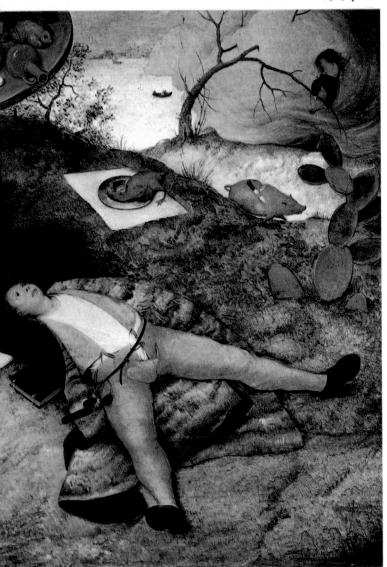

The Misanthrope 1568

Om dat de werelt is soe ongetru
Daer om gha ic in den ru

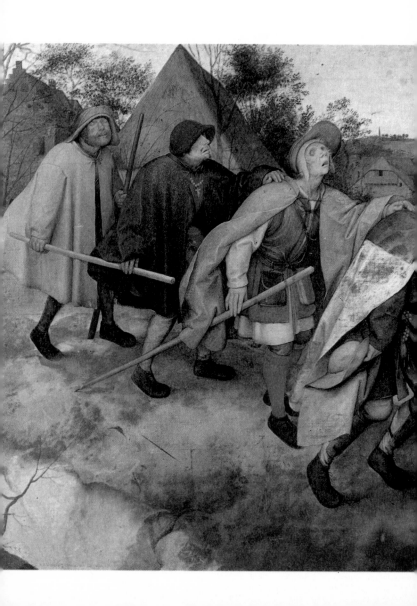

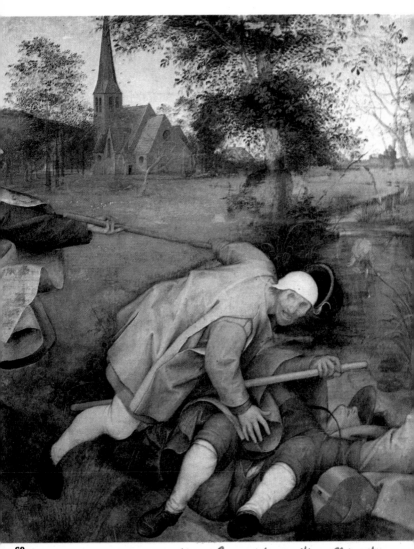

The Parable of the Blind
1568

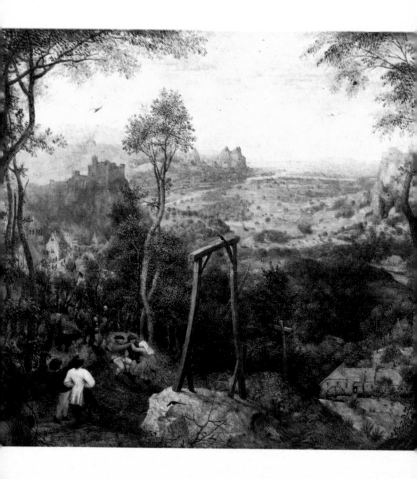

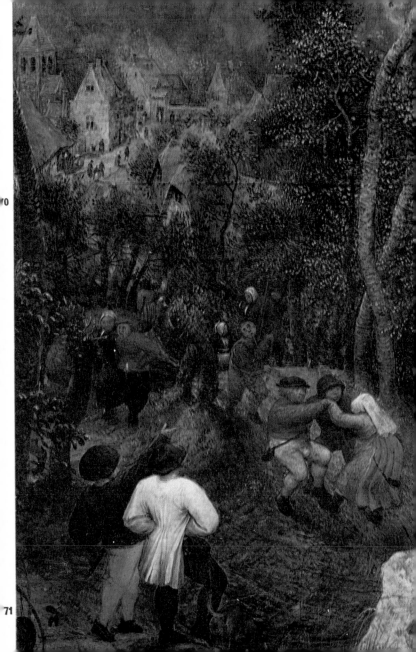

The Peasant and the
Bird Nester 1568

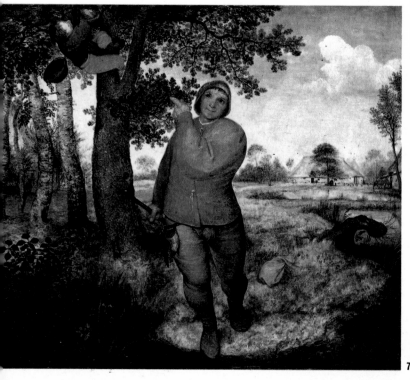

The cripples    1568

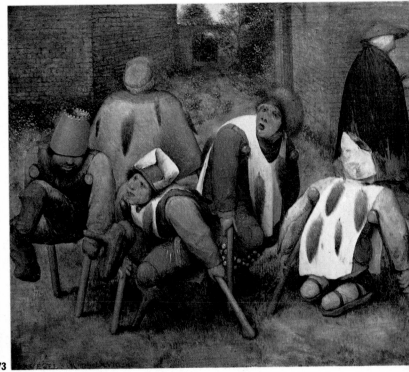

73

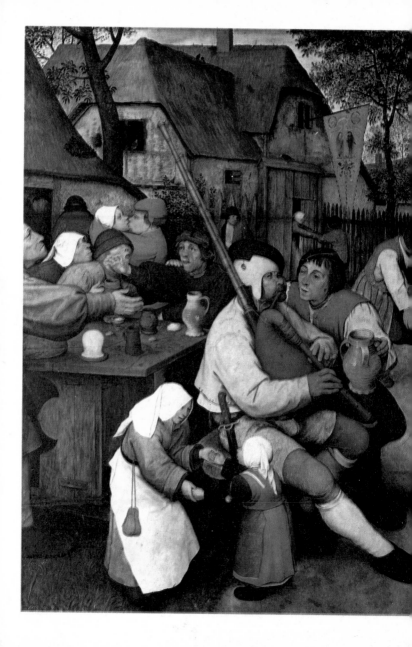

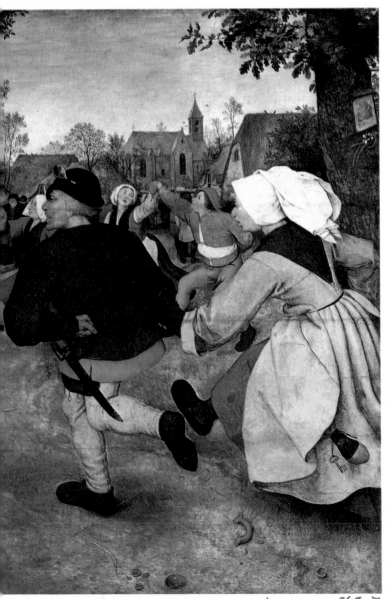

The Peasant dance 1565-7

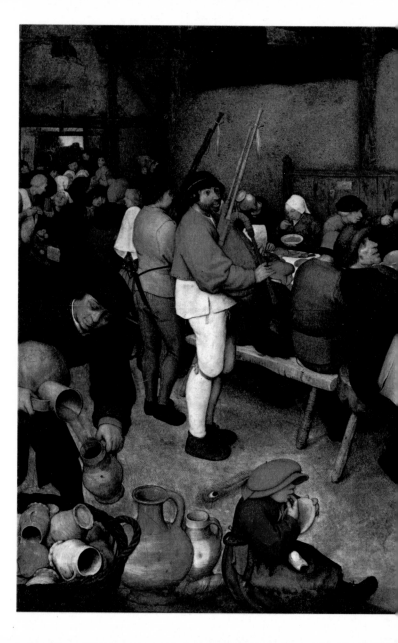

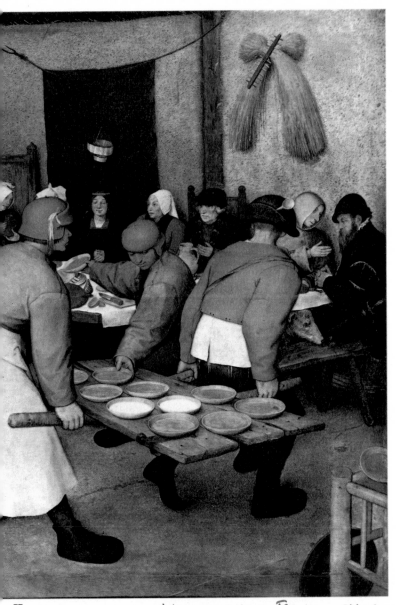

The wedding Feast 1566-9

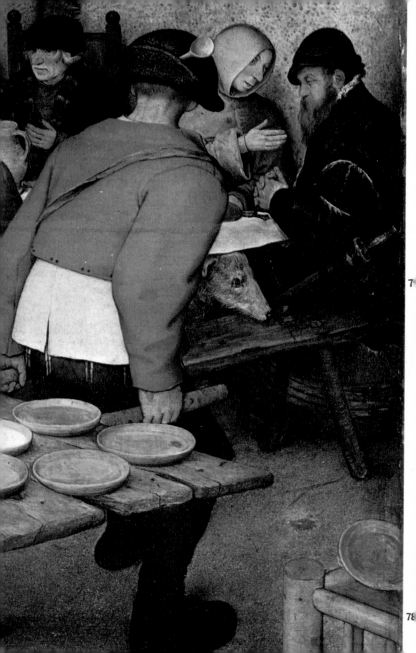

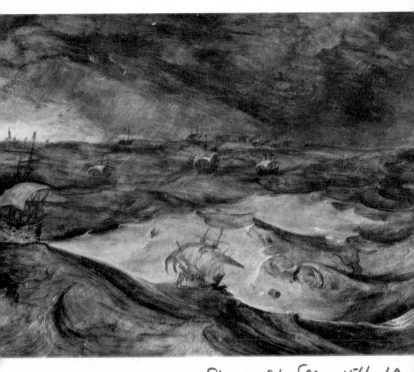

Storm at Sea 1566-69